IMAGES
of America

AFRICAN AMERICANS IN
AMARILLO

*thank you!
Leo ASHA
12.4 -10*

IMAGES
of America

AFRICAN AMERICANS IN
AMARILLO

Claudia Stuart and Jean Stuntz

ARCADIA
PUBLISHING

Published by Arcadia Publishing
Charleston SC, Chicago IL, Portsmouth NH, San Francisco CA

Printed in the United States of America

Library of Congress Control Number: 2008940087

For all general information contact Arcadia Publishing at:
Telephone 843-853-2070
Fax 843-853-0044
E-mail sales@arcadiapublishing.com
For customer service and orders:
Toll-Free 1-888-313-2665

Visit us on the Internet at www.arcadiapublishing.com

I wish to dedicate this book to the fine people of Amarillo who have shared so much of their heritage, legacy, and history with us. Also a special dedication and thanks go to my family Harold, Dietra, and Farrah for their support of this project. Dietra has a penchant for detail that proved invaluable indeed. To my mother, Claudia, and father, Sammie, for raising me to always remember where we came from and who we are. Thoughtful consideration also goes to my grandchildren, Raquelle, Christian, Jonathan, Langston, and Maya, as I challenge them to always appreciate from whence they have come; live for today and plan for tomorrow and, through God, all things are possible.

—Claudia Stuart

CONTENTS

ACKNOWLEDGMENTS

Nothing ever means anything to anyone unless and until you show them how much you care. This book, a labor of love, has brought us the great joy of seeing the smiles on people's faces as they shared their heartfelt stories of the past and present. To hear the women speak with pride of their children and their accomplishments and the men talk about how they have survived many trials and tribulations to get to where they are today was moving. The never-ending thread woven through the words they spoke was of Jesus and their abiding faith in the Lord. As the founders made their way to Amarillo to eke out an existence and build schools and churches, the trust in the Lord was powerful and the closeness of the families incredible. Thanks to all for sharing their stories, gathering articles, calling relatives, culling through family pictures and memorabilia, and giving of their time—all of which meant a great deal to us in this whole process. Special thanks go to Rev. Phillip Randle, Helen Neal, and Flournoy Coble for access to Johnson Chapel AME Church for interviews and archives. We thank Daniel Johnson, Gwen Williams, Willetta Jackson, James Vell and W. Jean McGhee, and Clemon and Lola Whitaker for their endless support of the project with pictures and oral histories. We appreciate being able to have interviews and gather pictures at the Amarillo United Citizens Forum, Inc. I wish to also thank my family, who were so supportive of this project and may have missed meals simply because we could not uncover the counter or tabletops for all of the many pictures. I will miss all of those faces peering back from the past. I am grateful to Jean, my colleague, for asking me to join in this endeavor. Those who heeded the call for pictures came willingly, and some even came often. For that, we are truly grateful. For others who heard and were unable to reply, perhaps this will spark an interest in others writing a book in the future about the wonderful and rich heritage shared by African American people living in Amarillo, Texas.

INTRODUCTION

The town of Amarillo began in 1887 as a collection of tents used by the men building the railroad through the Texas Panhandle and by the saloons that served them. It was derisively called Ragtown by the inhabitants of more civilized parts of the area. Soon, though, astute businessmen saw an opportunity to turn Ragtown into a real city. They bought the land near Amorilla Creek. This was a misspelling of Amarillo, the name given by Spanish explorers for the yellow grasses of the Southern Plains. The businessmen divided the land up into city lots and began businesses. They also named the new town Amarillo, though it was always pronounced in an English fashion rather than as a Spanish word.

The first black man to live in Amarillo was Jerry Calloway. He worked for a white family who moved to the area and brought him along. From the very beginning of black settlement, African Americans faced severe racial prejudices and stereotyping. Calloway went on to become an esteemed member of the African American community, known as Brother Jerry within the Mount Zion Missionary Baptist Church.

The second black man to live in Amarillo was Mathew "Bones" Hooks. Hooks had lived for several years in the panhandle, working as a cowboy at some of the large ranches. He was famous for being able to ride any horse, even those that threw off other riders. Cowboying in those days was hard, dangerous work, with cowboys often receiving life-threatening injuries on the job. Hooks was getting older, and he was too smart to keep being a cowboy, so he moved to the town of Amarillo in 1900 to work in a hotel and soon went to work on the railroad as a porter. Hooks earned the respect of both the white and the black communities. He was known for the white roses he put on the graves of the white pioneers of the area; he helped found the Panhandle-Plains Historical Association and built the Panhandle-Plains Historical Museum. Hooks also founded the Dogie Club for boys to give them job and life skills.

At first, all African Americans lived in a four-square-block area near downtown known as the Flats. Bones Hooks and others convinced the whites to "allow" the blacks to move farther from the white community, to high ground north of the town. Hooks bought the land to make this possible. North Heights became the center of the growing African American community. People built their churches and their businesses there. They built the Patten and Carver Schools also. They joined fraternal organizations, created their own YMCA, and finally built the Black Historical Cultural Center and the Martin Luther King Jr. Park there.

Fraternal organizations serving the African American community in Amarillo include the Zeta Phi Beta Sorority and the Omega Psi Phi Fraternity. Zeta Phi Beta Sorority, founded in the 1920s, seeks to address societal mores, ills, prejudices, poverty, and health concerns of the day. It started with five women at Howard University: Arizona Cleaver, Myrtle Tyler, Viola Tyler, Fannie Pettie, and Pearl Neal. These original five women, known as the Five Pearls to the sisterhood, worked toward scholarship, service, sisterly love, and finer womanhood. Zeta Phi Beta was the first Greek letter organization to charter a chapter in Africa in 1948. The Amarillo chapter,

started in 1966, has forever been consistent with the goals of the organization. They believe in community outreach services, educating the public, and assisting the youth.

Omega Psi Phi Fraternity began at Howard University in 1911. The founders were students Edgar A. Love, Oscar J. Cooper, and Frank Coleman. Their first motto was "Friendship Is Essential to the Soul." Omegas were active in the civil rights movement in the 1950s and 1960s. More recently, their work has been more educational and humanitarian, but they are still active in politics, especially in 2008. Dr. Richard Jones, Gillespie Wilson, Ike Avery, and Arthur Champion are some of the leaders of the Amarillo chapter. Other organizations include Delta Sigma Theta Sorority, Kappa Alpha Psi Fraternity, and Phi Beta Sigma Fraternity.

During the civil rights era, many meetings took place in the churches, and people fought to gain real freedom and equality. They opened businesses across town, marched to end segregation in public places, and got the right to vote. In short, they succeeded, and at last, African Americans of Amarillo were serving on the Amarillo City Council and Potter County Commissioner's Court and making names for themselves in many professions. Today the African American community still celebrates the past with Juneteenth parades, alumni reunions, and church gatherings. They also look to the future with Unity Day, the Martin Luther King Jr. holiday, and other events.

One

LEADERS

UPON THESE SHOULDERS

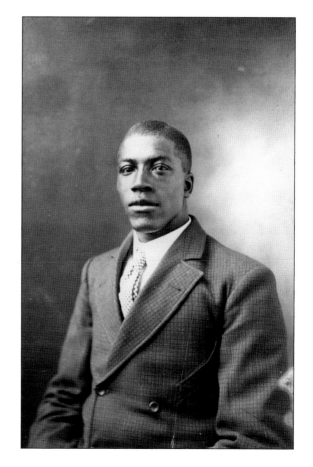

Mathew "Bones" Hooks got his nickname because he was so skinny as a boy. As a young man, his cowboy skills earned the respect of whites on the ranches of the Texas Panhandle. He bought land north of town in 1926 and helped create the North Heights community so blacks could live apart from whites. He created the Dogie Club for youths to teach them how to be successful. (Courtesy of Panhandle-Plains Historical Museum, Canyon, Texas.)

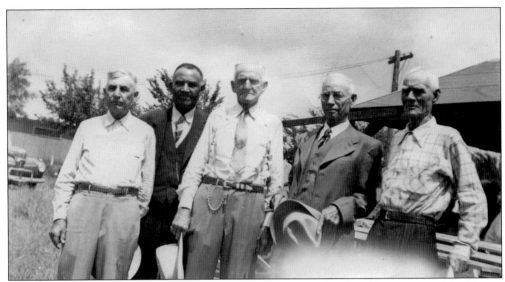

Bones Hooks identified himself as a pioneer and went to all of the old-timer reunions. He got along well with white people and used that skill to benefit the black community. His ability to ride any horse led to fame and friendships with influential people of the area and of the nation. (Courtesy of Panhandle-Plains Historical Museum, Canyon, Texas.)

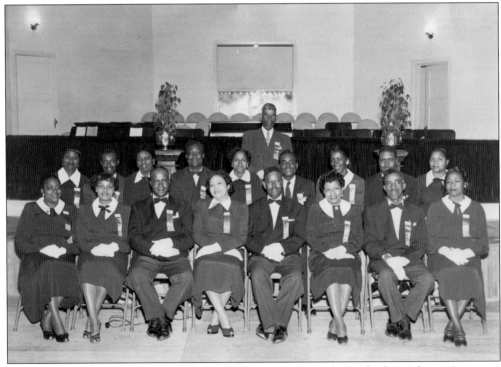

Jerry Calloway, standing in back of the Mount Zion Usher Board, was the first African American to live in Amarillo. He came with his employers in 1888 and later helped to found the Mount Zion Missionary Baptist Church. He protected the women who worked downtown by using a whip against the white men who harassed them. For this he was known as the bravest man in Amarillo. (Courtesy of Mount Zion Missionary Baptist Church.)

Prof. Silas C. Patten was named the first pastor of Johnson Chapel AME Church in 1928. He wanted all of the children to be educated and worked hard to achieve this. His house became a school, and later Patten School was named for him. The Patten family was very active in the community and gave of themselves to build a better place to live. (Courtesy of Daniel Johnson.)

In the 1920s, when white Amarillo was experiencing a burst of Ku Klux Klan activity, some black Amarillo residents formed the men's Leadership Group. Their purpose was to lead their community safely through difficult times and to inspire the youth to become educated and successful. While their names are unknown, their actions bore great fruit. (Courtesy of Daniel Johnson.)

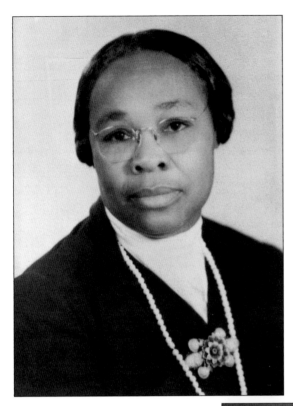

Rev. Inez Z. Chance oversaw the building of the parsonage of Johnson Chapel AME Church in 1949. Reverend Chance led through example. Just being around her made everyone want to be a better person, in part because they never wanted her to catch them doing anything bad. She had the honor and respect of many people from various congregations, not just Johnson Chapel AME Church, which was a testament to her leadership. (Courtesy of Johnson Chapel AME Church.)

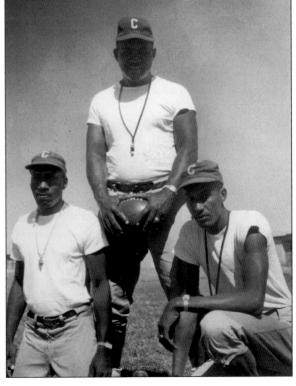

Pictured from left to right are Billy Hisbon, Johnny Allen, and Nathaniel Neal. They coached both football and basketball, and Allen coached track as well. Through sports, they changed the lives of many young men for the better. These men were also mentors outside the sports arena. Today they are still remembered and respected for their leadership and dedication to the community. (Courtesy of Jewelle Allen.)

Charles Warford was one of the founders of the Amarillo United Citizens Forum and served as its president. He owned the Warford Funeral Home for many years; later he added a partner, Richard Walker, and it became the Warford Walker Mortuary. As a prominent businessman, he and his wife, Wilma, have been very active in the community. He has mentored many youth through the years. (Courtesy of the Amarillo United Citizens Forum.)

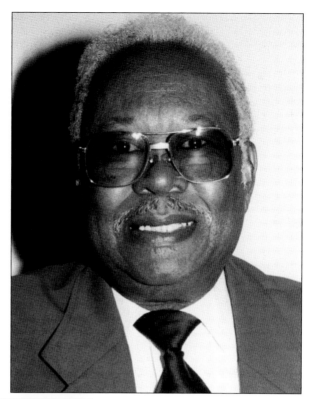

Clifford Austin owned the Austin Funeral Home, which began in 1936. He was known for running this successful business even through the Great Depression. He touched many lives through his business and got many people through difficult times. Actively involved in the community, he and his wife, Clarice, willingly gave support to many community endeavors. (Courtesy of the Amarillo United Citizens Forum.)

Marvell White was a hardworking, dedicated leader in the community. She started the Cultural House and later the Black Historical Cultural Center. She was very active in promoting Black History Month. She was the first African American woman to graduate with her master's degree from what was then West Texas State University. (Courtesy of the Amarillo United Citizens Forum.)

Here Marvell White (right) and Bertha Murphy stand in front of the Black Historical Cultural Center while it is being built. Miller worked as a nurse in Dr. J. O. Wyatt's hospital, which stood at the site of the cultural center. Bricks were purchased by members of the community as a fund-raiser to help pay for the center. Those contributors are now displayed on the building in its current location. (Courtesy of the Amarillo United Citizens Forum.)

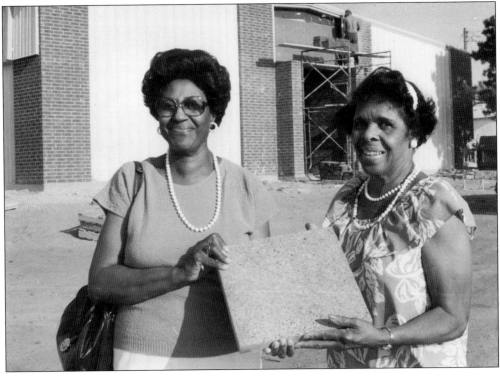

O. D. Nickerson was the contractor in charge of building the Black Historical Cultural Center. He has been a successful building contractor for many years and has developed many of the homes in North Amarillo. (Courtesy of the Amarillo United Citizens Forum.)

Eddie Lee Jones was the first African American to operate a trucking business in Amarillo and the first to get an interstate hauling license in 1972. His wife was Eloise. He is shown here with his first truck in the 1950s. The motto of Jones and Sons Trucking was "God Will Supply, but We must Apply." The company won the Northwest Texas Disadvantaged Business of the Year award from the Texas Department of Transportation in 1993. (Courtesy of Tommie Hamilton.)

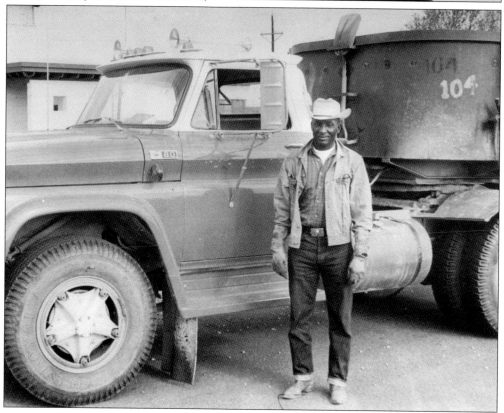

Lola Whitaker became Amarillo's first black female school principal in 1981, when she assumed that post at Robert E. Lee Elementary School. She has also been a leader in the NAACP and both the downtown and North Branch YMCA, as well as the Salvation Army and Habitat for Humanity. Since she retired in 1992, most of her time has been spent helping people in the community. (Courtesy of the Amarillo United Citizens Forum.)

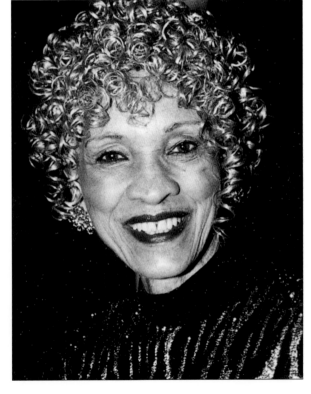

Ruby Lewis is famous in Amarillo as Lady Cool Breeze, the first African American disc jockey in the Texas Panhandle. She started her on-air career in 1954 playing jazz and rhythm and blues on KAMQ AM radio. She has been an inspiration to many with her can-do attitude, radiant smile, and glamorous wardrobe. (Courtesy of the Amarillo United Citizens Forum.)

Elisha Demerson's interest in politics began when he saw how much one person in government could help others. He decided to become that person. He was the first black county commissioner to be elected on a partisan ballot. He saw his political career, especially his time as county judge, as a way to be an advocate for every person who needed help. He was the first African American county judge in the state of Texas. (Courtesy of Elisha Demerson.)

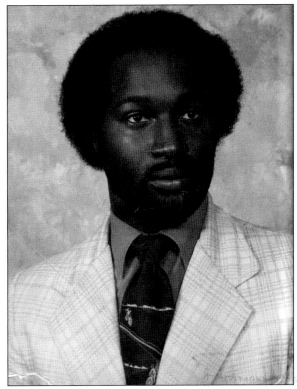

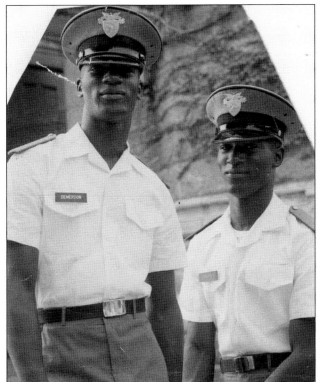

Pictured are Elisha and Elijah Demerson in their first year at West Point. They were the first black twins to enter West Point, which is, of course, a very prestigious institution. They have never been able to agree on which one is which in this picture, taken in July 1969 in front of Cadet Chapel. (Courtesy of Elisha Demerson.)

Iris Sanders Lawrence is a true leader who struggled to break down the color barriers in Amarillo and throughout Texas. She was the first black woman to work the floor at an Amarillo department store, the first black supervisor over the cutting room at Levi Strauss on Amarillo Boulevard, one of the first black women to work for the Texas State Comptroller's Office, and the first to serve on the Texas Board of Pardons and Paroles. She became a Potter County commissioner in 1998 and served for eight years. Here she is with her brother, Virgil Sanders, at a Carver reunion. (Courtesy of the Amarillo United Citizens Forum.)

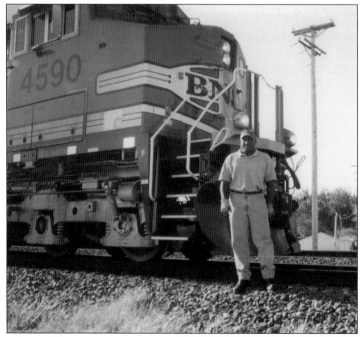

Harold H. Stuart became the first African American railroad engineer for Santa Fe Railway in Amarillo in 1974. It is now known as Burlington Northern Santa Fe (BNSF). Stuart is an alumnus of West Texas State University, where he was a football standout playing linebacker for the legendary coach Joe Kerbel. Stuart was known as "Gentle Ben." He is also a member of Omega Psi Phi Fraternity, Inc. (Courtesy of Claudia Stuart.)

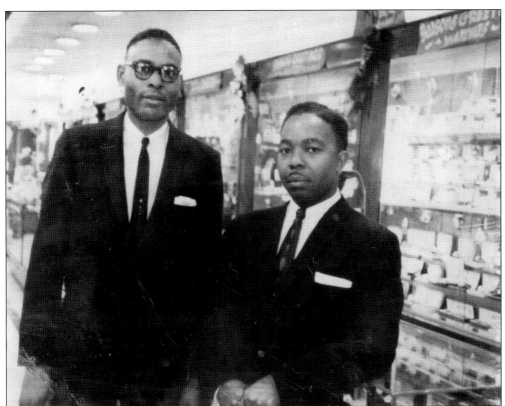

Mike Thomas (left) and Jesse Parrish are pictured in a Zales jewelry store. Jesse Parrish was the first African American salesman for the company in Amarillo. He began this position in 1967. Though it took some customers a while to get used to him, Parrish always provided superior customer service. (Courtesy of Elizabeth Randle.)

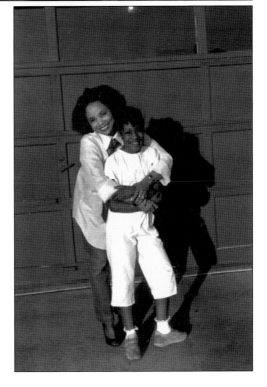

Carmen Katrina Lott (left), pictured with Farrah Stuart, was the first successful African American screenwriter from Amarillo. She had worked many years in New York City before finally realizing her dream to move to Hollywood and work in the motion picture industry. Carmen was a Carver graduate and later graduated from West Texas State University. During the summers, she would return to Amarillo to hold her actor's workshop and have plays and other cultural events with youth and adults. (Courtesy of Claudia Stuart.)

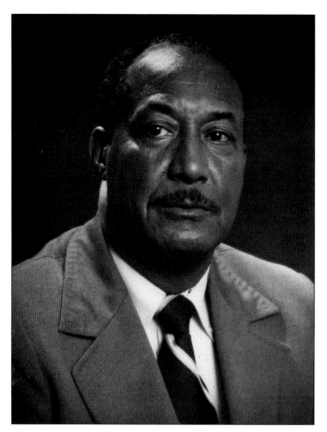

Nathaniel J. Neal began teaching and coaching at Carver High School in 1955. In 1959, he became the assistant principal at Carver and, in 1968, began teaching at Amarillo College and West Texas State University. He was dean of the vocational arts and allied health departments at Amarillo College from 1974 to 1983. He continued teaching at Amarillo College and West Texas State University until 1992. (Courtesy of Helen Neal.)

Throughout his career, Neal mentored every young person he could. Whether he took them out pheasant hunting or counseled them on their careers, he made a major difference in their lives. To honor him posthumously for his service to the community, the Texas Department of Criminal Justice named the Amarillo women's prison unit for him. There the women get counseling and training to help them when they reenter society. (Courtesy of Helen Neal.)

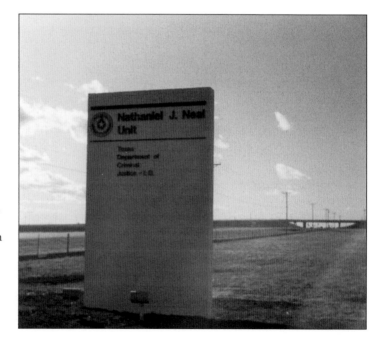

Helen Neal was the first African American woman to graduate from West Texas State University in 1962. She taught at North Heights and Humphrey's Highland Elementary Schools for 20 years. After her retirement in 1983, she became even more active in the community, mentoring at the North Branch YMCA, leading her daughter's Girl Scout troop, establishing the "Lift Every Voice" concerts, volunteering at the Black Historical Cultural Center, and more. (Courtesy of Helen Neal.)

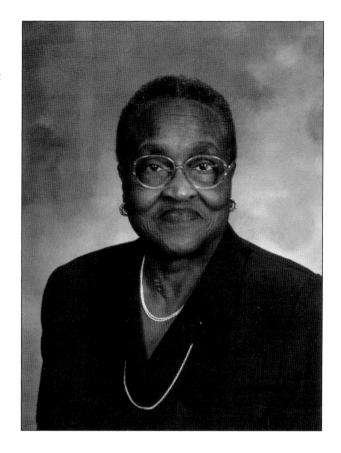

Helen Neal is shown at the ribbon-cutting ceremony opening the prison's Nathaniel J. Neal Unit in 1994. She remains a leader of the community, serving on the boards of the Amarillo College Foundation, the Jan Werner Adult Day Care Center, and the Amarillo United Citizens Forum. She is a member of Delta Sigma Theta, the NAACP, and Johnson Chapel AME Church. (Courtesy of Helen Neal.)

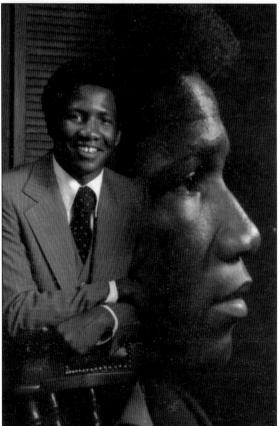

Lisa Cherry, pictured here with her mother, Merylen Davis (seated), and her sister, Angela Allen (standing in rear), served on the Amarillo College Board of Regents from 2000 to 2006. When she was diagnosed with cancer, the community rallied around her, and many people came together in the Walk for the Cure events. She was the first African American female police officer in the city of Amarillo. (Courtesy of the Amarillo United Citizens Forum.)

James Allen, a graduate of Morehouse College, was the first African American elected to serve on the Amarillo School Board. He was a board member from May 1999 to April 2000, when he was elected to be school board president. He served in that capacity from May 2000 to 2004. He also served as the community development advisory committee chairman for the creation of the Dr. Martin Luther King Jr. Park. (Courtesy of Jewelle Allen.)

Jewelle Allen is shown here with Buddy Allen at the dedication of the Jewelle Allen Center Stage in Bones Hooks Park on June 14, 2008. Jewelle Allen taught school for 17 years at Carver High and another 17 years at Palo Duro High School. She has been a community leader for a long time. Among other honors, she became grand deputy of the Order of the Eastern Star in 1991. (Courtesy of Jewelle Allen.)

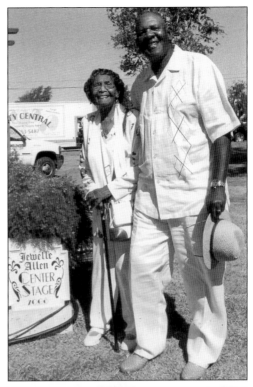

Cecil Jackson, shown here with his wife, Brenda, was the first African American grocery store manger in Amarillo. He is a longtime resident of the city. Brenda Jackson is a longtime member of the Delta Sigma Theta Sorority and is very active in the community with programs to feed the poor and help the needy. Also she participates each year with the Delta Deb and Beau Debutante presentation with her sorority. (Courtesy of the Amarillo United Citizens Forum.)

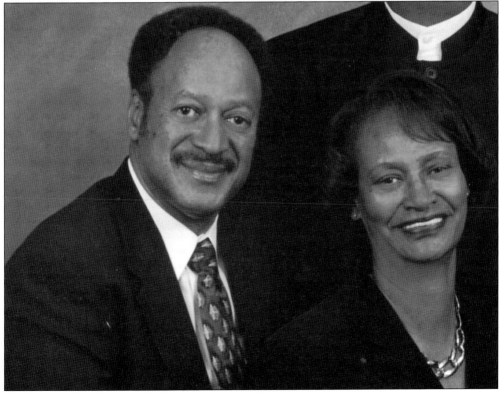

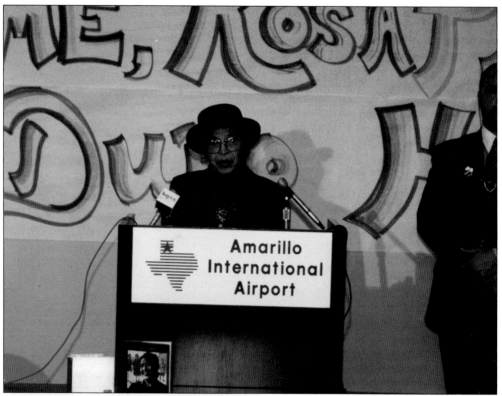

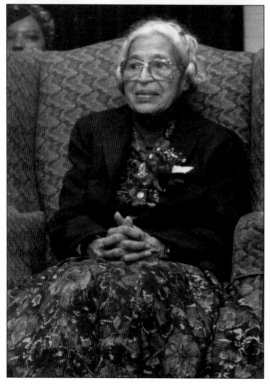

Rosa Parks, famous for her role in the Montgomery bus boycott and the civil right movement, visited Amarillo in February 1996. She gave a press conference at the Amarillo airport. She spoke about her arrest for non-violent protest, her foundation for young people, and her faith, which gave her strength during that ordeal. (Courtesy of Claudia Stuart.)

Parks visited West Texas A&M University as one of the many stops in her brief three days in Amarillo. Her meeting in Canyon was attended by well over 800 people who came by school buses, vans and cars. The message of "The Mother of the Civil Rights Movement" was the responsibility of young people to take the lessons of the past and make a more just and better world. Rosa Parks had almost single-handedly set in motion a veritable revolution that would eventually secure equal treatment under the law for all black Americans. (Courtesy of Claudia Stuart.)

Rosa Parks addressed a crowd of approximately 1,500 at the Amarillo Civic Center. The soft-spoken Rosa Parks was so much more than the woman who refused to give up her seat on the bus. She was presented with a proclamation from the City of Amarillo by Mayor Kel Seliger. (Courtesy of Claudia Stuart.)

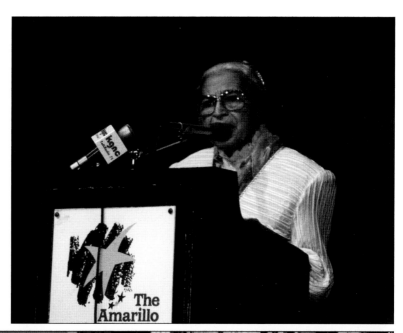

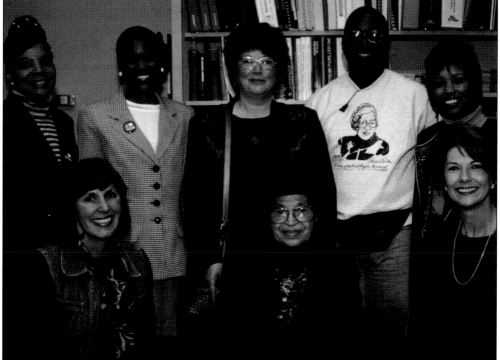

As Rosa Parks was planning her nationwide tour of cities traveled in the Underground Railroad, Amarillo was included. Barbara Dunn served on her national planning committee and is pictured here along with members of the Amarillo Rosa Parks Committee, chaired by Claudia Stuart. Those pictured are, from left to right, (first row) Patty Schneider, Rosa Parks, and Toni Cline; (second row) Elaine Steele, Claudia Stuart, Sue Cohen, Keith Grays, and Barbara Dunn. (Courtesy of Claudia Stuart.)

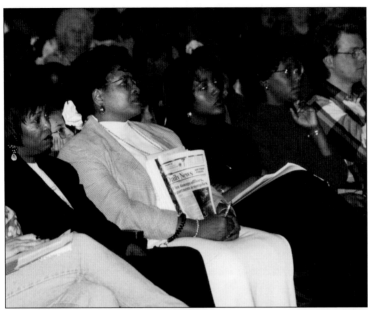

Palo Duro High School was a very important stop on the Rosa Parks tour of the city. Well over 1,900 students and adults attended her presentation. She traveled with an entourage of entertainers performing skits and orations on civil rights issues. A Visionary Award was given to Rosa Parks by King Hill and the students of Palo Duro High School. (Courtesy of Claudia Stuart.)

Many people in Amarillo have gone to Atlanta, Georgia, to the Dr. Martin Luther King Jr. Memorial. This picture was taken by Arvella Rowe during a Daughters of Isis trip. The Dr. Martin Luther King Jr. Park at 1501 Amarillo Boulevard was dedicated on January 15, 2000. It features a walking trail and pavilion. (Courtesy of Arvella Rowe.)

Willie Ford, of Fords Limousine Service, provided the transportation for Rosa Parks throughout her Amarillo visit in 1996. Willie Ford is always willing to lend his services to provide adequate transportation coverage for community organizations and nonprofits when called upon to do so. Pictured from left to right are Willie Ford, unidentified, Farrah Stuart, and Harold Stuart. (Courtesy of Claudia Stuart.)

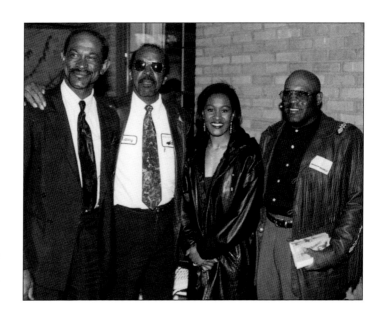

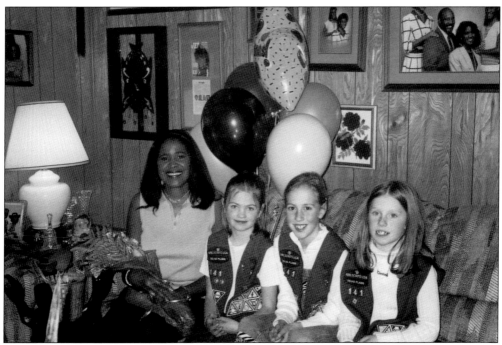

Claudia Stuart has been involved in many aspects of community leadership. She is the first African American female faculty member at West Texas A&M University and teaches in the sociology and criminal justice fields. She is a published author, artist, and poet and spends a great deal of time mentoring youth and speaking publicly. Also a community activist, while regional director for the Texans War on Drugs, she initiated prevention efforts across the region working with community, law enforcement agencies, churches, and schools. Here she is being recognized by the Girl Scouts of Texas, Oklahoma, Plains, Inc. (Courtesy of Claudia Stuart.)

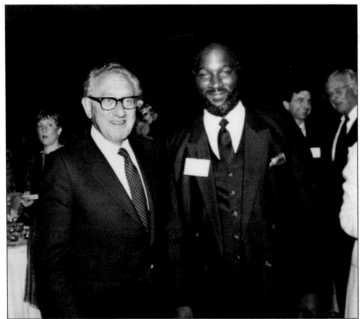

Dr. Henry Kissinger, then secretary of state for Pres. Richard Nixon, came to Amarillo for a local political event. He is standing next to Elisha Demerson. Jerry Jerome Johnson is at right in the back of the picture. Amarillo hosted many political events regarding world affairs during the turbulent 1960s and 1970s. (Courtesy of Elisha Demerson.)

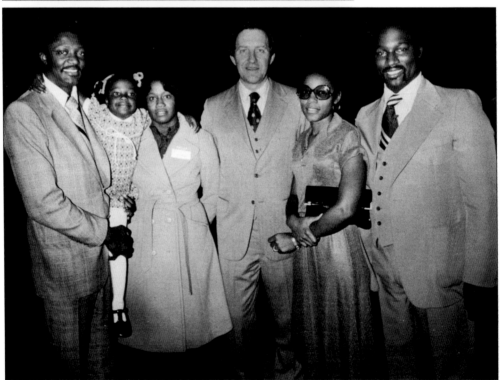

Congressman Bob Kruger (center) visited Amarillo in the mid-1980s. He is shown here with Elisha Demerson and his wife, Bobbie, on the right and Morris Overstreet on the left with his daughter Elizabeth and his wife, Brenda. Morris Overstreet became a court at law judge and later was the first African American statewide office holder when he took his place on the Court of Criminal Appeals. (Courtesy of Elisha Demerson.)

Fransetta Mitchell Crow is shown here with former president Bill Clinton. Clinton came to Amarillo to campaign for his wife, Hillary Rodham Clinton, in the Democratic primary of 2008. Crow has been very active in the community, including serving as a Potter County deputy sheriff. She was the first African American woman to run for Amarillo city commissioner in 2007. (Courtesy of Fransetta Mitchell Crow.)

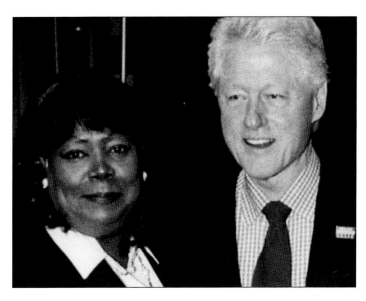

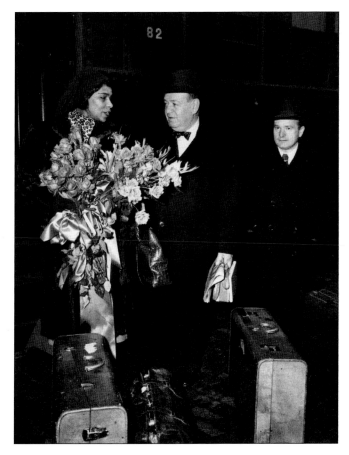

Renowned singer Marian Anderson came to Amarillo not long after the controversy with the Daughters of the American Revolution. Anderson had been scheduled to give a concert in their hall, but the DAR would not let her perform because of her race. The concert was moved to the Washington Mall, where Anderson gave her famous concert from the steps of the Lincoln Memorial on April 9, 1939. (Courtesy of Amarillo United Citizens Forum.)

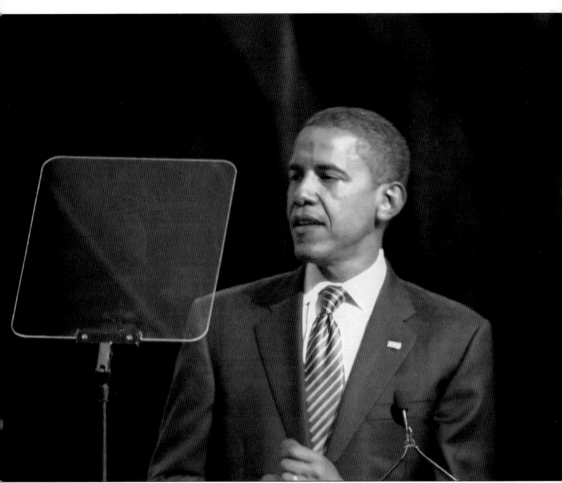

Then senator Barack Obama spoke at the 47th General Conference of the African Methodist Episcopal Church. Presidential nominee Barack Obama addressed the bishops and conference delegates about the direction in which he would lead the nation and enlisted the support of the body. Claudia Stuart attended the conference representing the 10th Episcopal District of Texas. Obama went on to capture the hearts and minds of the majority of the U.S. population and become the president of the United States. Many people in the African American community worked in his election campaign. (Courtesy of Claudia Stuart.)

Two

FAMILIES
GETTING TO KNOW YOU

Even though Amarillo started with only a few African American families, the African American population according to the 2000 census for Amarillo was 10,358, or 6 percent of the total population for Amarillo at 173,627. All of the families could not be depicted here, but a few have been. Pictured is the Knighton family, including, from left to right, Carlotta, Rosemary, Betty Sue, and Clothilde along with their children. (Courtesy of Willetta Jackson.)

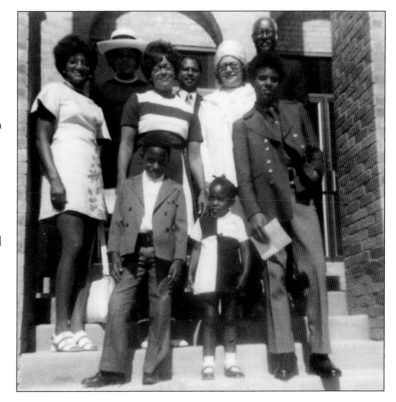

Oscar and Beverly Shorten are longtime Amarillo residents, and both are faithful members of Mount Zion Missionary Baptist Church. They had one son, Oscar Jr., and the Shorten name represents the pioneering background of the family. They helped organize Mount Zion Missionary Baptist Church and were property owners. (Courtesy of Willetta Jackson.)

Milmon and Iva Kelley were longtime members of Mount Zion Missionary Baptist Church who moved to Amarillo from Houston and Centerville, respectively. Milmon worked as a supervisor at Bell Helicopter and was later transferred to Houston. Iva was a schoolteacher in the Amarillo Independent School District and was a member of Delta Sigma Theta Sorority, Inc. (Courtesy of Willetta Jackson.)

The Lott family was well known in Amarillo and owned Lott's Barbeque. They were very interested in education and seeking a better place to raise a family. Those pictured are, from left to right, Beth, Fannie, Carmen Katrina, and Wilma. (Courtesy of Willetta Jackson.)

Pictured on the steps of Mount Zion Missionary Baptist Church are members of the Vaughn family— from left to right, Sandra, Alphonso, and Jimmie along with the children of Alphonso. Jimmie, a graduate of West Texas State University, now lives in Washington and works for the Pentagon. Alphonso has served the community in numerous ways. He was the president of the NAACP for a number of years and now is a Potter County commissioner. (Courtesy of Willetta Jackson.)

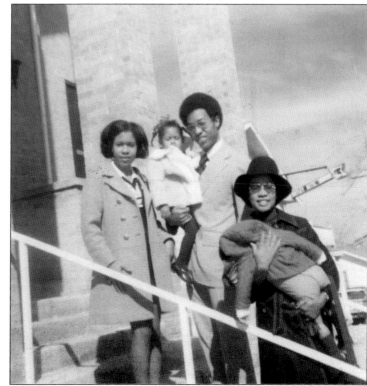

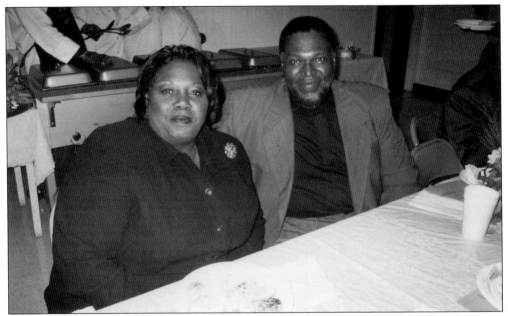

Roushell (right) and Tommie Hamilton are members of Johnson Chapel AME Church, where Tommie serves as president of the Stewardess Board and church secretary. Roushell serves on the Finance Committee and Steward Board. They have a son, Roushell Jr., a graduate of West Texas A&M University, who is also very actively involved in church activities and serves as superintendent of the church school. (Courtesy of Johnson Chapel AME Church.)

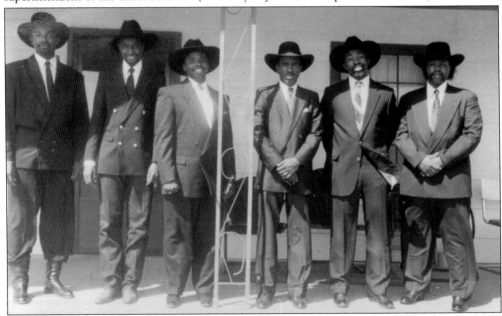

Known throughout Amarillo for their tall cowboy hats and boots, these men are the Jones bothers who own Jones Trucking Company. Pictured from left to right are Michael, David, Steven, Lee Artist, Delaware, and Phil. Eddie Lee Jr. and Judge Thomas Jones are not pictured. The business was started by their father, Eddie Lee Jones, the first African American in the state of Texas licensed to haul interstate. (Courtesy of Tommie Hamilton.)

James and Rosie Hood, pictured here in 1983, have a very large family in Amarillo. They hold annual family reunions to bring members together from all parts of Texas and the United States. They have held these gatherings in various parks throughout the city. (Courtesy of Betty Hood.)

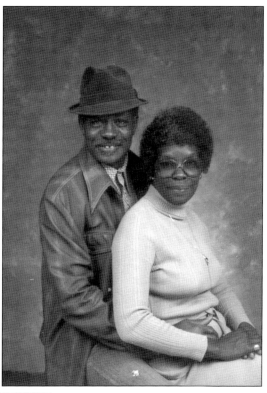

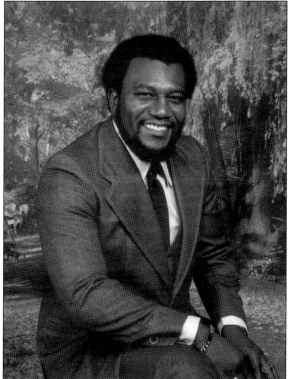

Lorenzo Woodberry, pictured here, is very active in Johnson Chapel AME Church, serving on the Steward Board and singing in the JC Men's Choir. He is a longtime resident of Amarillo and a member of Phi Beta Sigma Fraternity, Inc. The fraternity is constitutionally linked with the Zeta Phi Beta Sorority, Inc. They sponsor various community programs throughout the year, especially the Mary Hazelrigg Christmas Party for children. (Courtesy of Lorenzo Woodberry.)

Susan Woodberry Route, daughter of Lorenzo and Paula Wilburn Woodberry, is pictured with her husband, Don Route. Susan is a graduate of Palo Duro High School, Amarillo College, and Texas Tech University. A former member of Johnson Chapel AME Church, she now resides with her husband in Corpus Christie. (Courtesy of Lorenzo Woodberry.)

Shown here is Joe Mitchell, a member of the pioneering Mitchell family. He owned Mitchells Café, located in the Flats in 1946. In addition to being active church members, he and his brothers were prominent figures in the community. (Courtesy of Fransetta Mitchell Crow.)

Pictured is Frank Mitchell Jr., a native of Guthrie, Oklahoma, who moved with his father to Amarillo around 1918. He is the son of Mollie and Frank Mitchell, businessman and property owner. Frank Mitchell Sr. was a faithful member of the NAACP until his death in 1938. (Courtesy of Fransetta Mitchell Crow.)

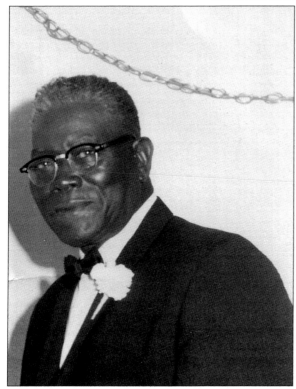

In 1946, Hershal Mitchell owned a grocery store and liquor store and later became a self-employed landscape contractor. He was a deacon in New Hope Baptist Church and the husband of Lena Mitchell. To their union, 12 children were born. He had two daughters from an earlier marriage, Frankie and Vera, and with Lena, he had David, Morris, Hershal, Fredrick, Victor, Brenda, Carol, Darlena, Fransetta, Betty, Margaret, and Connie. (Courtesy of Fransetta Mitchell Crow.)

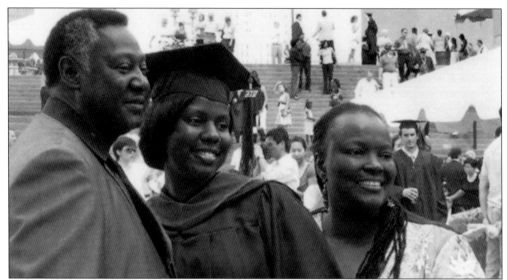

Ron (left) and Dr. Gwen Williams (here in 2007 with their daughter Tasha, center) share a celebratory moment honoring Tasha receiving her master's degree in biomedical engineering from the University of Akron in Akron, Ohio. Ron and Gwen own and operate the Beadz Shop in Puckett Plaza Mall in Amarillo, Texas, where they teach beading classes and sell semiprecious stones and jewelry. Dr. Williams is a professor at West Texas A&M University. (Courtesy of Gwen Williams.)

The Doves—from left to right, (seated) Dr. Dennis and Claudette; (standing) their three boys, Daniel, Domonic, and Damien—moved from Fort Lauderdale, Florida, to Amarillo in 1999 so Dennis, a physician, could become a professor and chairman of the Department of Surgery at Texas Tech University and Health Sciences Center (TTUHSC). He also serves as the chief of trauma at Northwest Texas Healthcare Systems. Claudette was the founding administrator for the Laura W. Bush Institute for Women's Health at TTUHSC. Domonic and Daniel are twins and juniors at the University of Florida in this picture. Damien is a freshman at Pepperdine University in Malibu, California. (Courtesy of Claudette Dove.)

Three

CHURCHES
LARGE AND SMALL

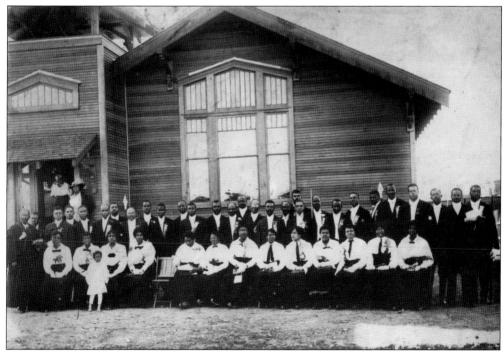

In 1909, there were few black folk in Amarillo and no church for the people to congregate and worship in. Bible class and prayer meetings were held in the homes of individuals. Later in the year, a lot was acquired on the north side of the Rock Island track, and a small building was moved there for services. The building was burned down the same night. In 1910, services were moved to Harrison Street in the home of Lula Pierson Gray, the Bible class teacher and a strong promoter of the movement to build a church. Mount Zion Missionary Baptist Church was organized in 1910. (Courtesy of Willetta Jackson.)

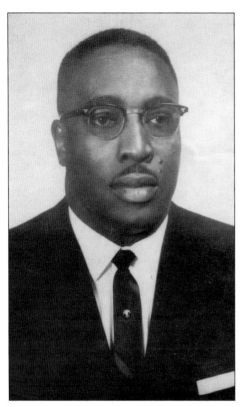

Those instrumental in the organization of the Mount Zion Missionary Baptist Church included Jerry Calloway, the first black man in Amarillo. Mathew "Bones" Hooks, although never really affiliating with any church, certainly assisted in procuring property and approvals in land acquisitions for church buildings. Others were Frank Martin, Sam McNeil, J. H. Cleveland, Max Pain, Lula Pierson Gray, and J. D. Gray. Rev. Miles Jenkins was the pastor. The First Baptist Church of Amarillo assisted in 1916 with the site and frame church structure. Members also served on the board; this showed that whites in power approved of the black church, so it was no longer a target of racism, and the church burning ended. Once finished, the cornerstone was laid, and the dedication occurred in 1916. After the dedication, Reverend Manorgan was called to preach; the trustees were Phillip Shorten Sr., Frank Martin, Sam McNeil, Max Pain, Martin Jefferson, Dr. J. E. Nunn, W. H. Fuqua, and attorney Herman Pipkins. Pictured is Rev. Louie B. George, who later served as pastor of Mount Zion Missionary Baptist Church. (Courtesy of Mount Zion Missionary Baptist Church.)

Standing on the steps of Mount Zion Missionary Baptist Church is Nelson Huff Sr., a lifelong member of the church and member of the Trustee Board. He was the owner of Huff's Drugs on North Hughes Street, a frequent gathering place for many in the community, old and young alike, talking about community events, politics, sports, and cultural changes. (Courtesy of Willetta Jackson.)

Dr. M. P. Hines was a local dentist and member of Mount Zion Missionary Baptist Church serving as a member of the Trustee Board. Dr. Hines and his wife, Kathryn Oliver Hines, were a very prominent family in the black community and used the arts, especially music, to enhance the lives of young people. Kathryn Hines taught music lessons for many years and was well known throughout the Amarillo community for her grace, talent, and philanthropy. (Courtesy of Willetta Jackson.)

Wilmont Lott was a lifelong member of Mount Zion Missionary Baptist Church and a local businessman. He was the owner of Lott's Barbeque, and many young people frequented it for the fine food and soda shop. Even years later, people remembered how good the food was at Lott's Barbeque. (Courtesy of Willetta Jackson.)

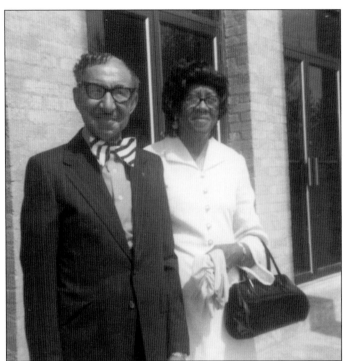

Pictured are Rev. R. E. Manning and his wife, Jessie, at Mount Zion Missionary Baptist Church. Reverend Manning was first an active and involved member of Mount Zion Missionary Baptist Church and later served as the pastor. (Courtesy of Willetta Jackson.)

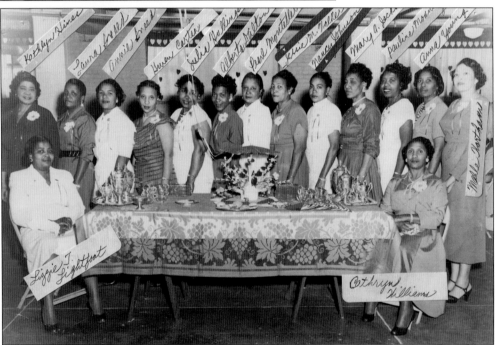

The Esther Circle in 1956 met regularly for Bible study and fellowship. They held a Valentine Day Tea each year, and the members included, from left to right, Lizzie Lightfoot, Kathryn Hines, Laura Sneed, Annie Sneed, Gwen Carter, Julia Hollings, Alberta Dalton, Pearl Monteller, Jessie Walker, Nancy Johnson, Mary Jackson, Pauline Moaning, Anna Young, Mable Wortham, and Cathryn Williams. (Courtesy of Willetta Jackson.)

Gathered together outside of Mount Zion Missionary Baptist Church were members of the Junior Class. Each class had a strong bond that could last for years, even after they went their separate ways. (Courtesy of Willetta Jackson.)

Prior to Sunday morning services, father and daughter Morris and Elizabeth Overstreet prepared for the services. Morris Overstreet, a local attorney, was very active in the church and served the community as an assistant district attorney. He later served as judge in the Texas Court of Criminal Appeals and was the first African American elected to a state office from Amarillo (1990–1992 and 1993–1998). (Courtesy of Mount Zion Missionary Baptist Church.)

Willetta Jackson, a lifelong member of Mount Zion Missionary Baptist Church, serves as the church clerk and historian. Her mammoth job includes organizing and maintaining church records and archives and welcoming and introducing church visitors during Sunday morning worship service. She comes from a long line of family members holding property and businesses in Amarillo. (Courtesy of Mount Zion Missionary Baptist Church.)

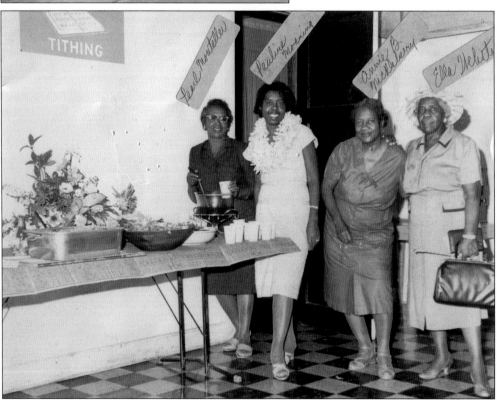

Members of the Women's Missionary Society held many receptions and church socials throughout the year in addition to spreading the Gospel through continued service in the community. Members included Pearl Monteller, Pauline Moaning, Annie Nickelberry, and Ella Webster. (Courtesy of Willetta Jackson.)

Members of the Young Matron's Circle of Mount Zion Missionary Baptist Church in 1948, shown with Rev. F. N. Marshburn, included, from left to right in the first row, Bertha Huff, Pastor Marshburn, and Mabel Mitchell (president of the Women's Missionary Society); (second row) Beth Harper Mayberry, Lena Mitchell (teacher), Hazel Gipson, Eva Mae Brown (president of the Young Matron's Circle), Pearlene Williams, Etoye Williams (secretary), Alma Jenkins, Pauline Parker, and Mildred McDonald. (Courtesy of Mount Zion Missionary Baptist Church.)

The youth of Mount Zion Missionary Baptist Church carry the banner of the church and participate in church activities. Pictured are Elizabeth Overstreet (right) and others sharing in fun and fellowship. The church motto is "Mount Zion Missionary Baptist Church is the friendly church on the corner where we enter to worship and depart to serve." (Courtesy of Willetta Jackson.)

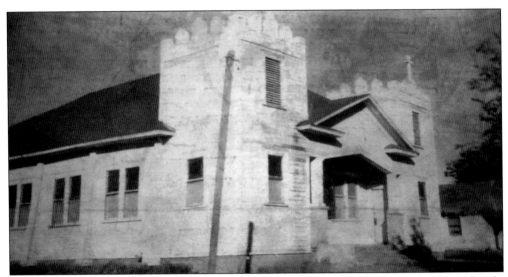

When first organized in 1907, Carter Chapel was named "The People's Church." The first church, pictured, was built in 1918 under the leadership of Rev. J. S. Starks. Trustees included D. I. Rainey, H. Taylor, M. C. Johnson, M. H. Carter, and Ed Moore. Over the years, the name evolved into Carter Chapel Colored Methodist Episcopal Church. (Courtesy of Clemon Whitaker.)

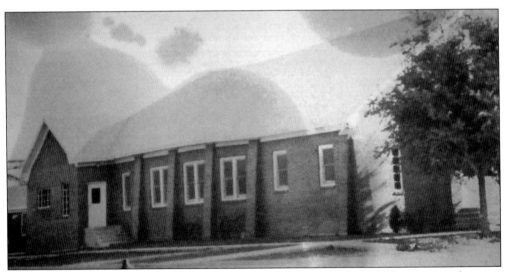

This is Carter Chapel Colored Methodist Episcopal Church around 1956. The pastor at the time, Rev. V. L. Brown Sr., oversaw major renovations to the church. A carpenter by trade, Reverend Brown remodeled and bricked the building. Another structural change was the moving of the church entrance. (Courtesy of Clemon Whitaker.)

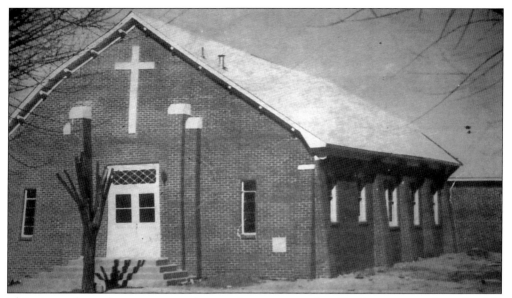

This picture shows that more external renovations were completed by the trustees and membership of Carter Chapel CME Church. In 1964, the General Conference voted to change the name of the church from Carter Chapel Colored Methodist Episcopal Church to Carter Chapel Christian Methodist Episcopal Church. (Courtesy of Clemon Whitaker.)

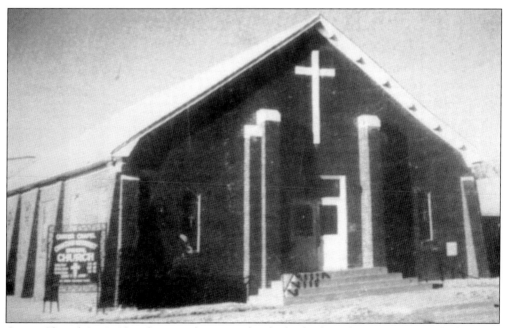

Carter Chapel CME Church, around 1970, under the leadership of Rev. C. C. Campbell, pastor, had completed still more exterior renovations, including removing the large tree in front of the entrance and putting up signage depicting the new official name of the church in its current location at 412 Southwest Second Avenue. (Courtesy of Clemon Whitaker.)

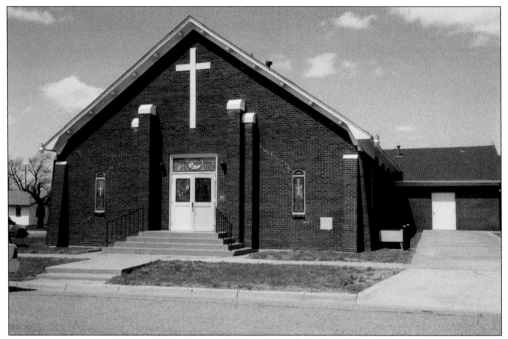

The present-day Carter Chapel CME Church says, "This is our Church! Where through the years true men of God have spoken words of light—With Spirit-filled words have pointed men aright—up the straight road that leads from paths of night into the light of Heaven, this is our Church!" (Courtesy of Clemon Whitaker.)

Dr. J. O. Wyatt (pictured) came to Amarillo and found a church home at Carter Chapel CME Church. He was also here to practice medicine. Although he was not able to practice in white hospitals, he responded to the needs of the black community by opening his own clinic in North Amarillo. His facilities occupied an entire city block, which he owned, complete with living quarters for the nurses who worked with him, Margaret Sanders and Billie Murphy. Currently the Black Historical Cultural Center is located on this site. (Courtesy of Clemon Whitaker.)

In 2007, Carter Chapel had its 100th church celebration. Pictured is Rev. Bobby Powell Sr. (left), pastor, originally from Fort Worth, Texas. The master of ceremonies for this service was Clemon Whitaker (second from left). Also pictured are, standing, Presiding Elder Raymond McKever (representing the Abilene, Wichita Falls, and Amarillo Districts) and, at right, Presiding Elder Andrew Nance (representing the Lubbock, Midland, and Odessa Districts). (Courtesy of Lola Whitaker.)

Kappa Silhouettes are wives of Kappa Alpha Psi Fraternity members. The Kappa Silhouettes hosted social entertainment for wives of visiting chapter members in Amarillo for regional meetings and conferences. Included in this picture are Maxine Gayles, Helen Neal, Lavern Hilliard, Juanita Ammons, Greta Blackburn, Ruth Scott, Bernice Harkins, and an unidentified Silhouette. (Courtesy of Lola Whitaker.)

John Lee Sr. receives his Certificate of Appreciation for 60-plus years of service and commitment to Carter Chapel CME Church during the 100th church celebration. Lee was the church treasurer for 20 years. At the time of the celebration, he was the oldest living steward and trustee. He was also a member of the men's Sunday school class. (Courtesy of Clemon Whitaker.)

Mary C. Jones receives her Certificate of Appreciation for 60-plus years of service and commitment to Carter Chapel CME Church during the 100th church celebration. Jones was a stewardess for about 20 years as well as a member of the Women's Missionary Society. She also helped prepare meals for church dinners and socials. (Courtesy of Lola Whitaker.)

Elliott Mann was encouraged to join the Carter Chapel CME church family by Clemon Whitaker. Once he joined, Elliott Mann was considered a "dedicated and dutiful" member and never faltered in his commitment. He was recognized for his years of service as a steward and trustee at the 100th church celebration in April 2007. (Courtesy of Clemon Whitaker.)

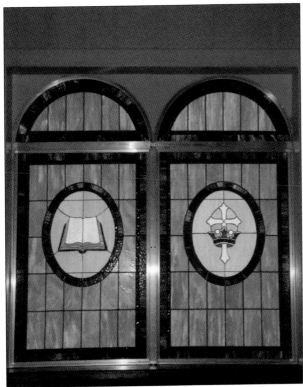

Longtime members of Carter Chapel CME Church, John and Elnora Jackson made provisions in their will for the purchase of the stained-glass windows pictured here. Elnora Jackson served many years as church secretary, president of the stewardesses, Missionary Society member, and choir president. John Jackson's 50-plus years of service included Steward Board chairman and senior high Sunday school teacher. As a trustee, he oversaw church renovations and furniture purchases. The Jacksons attended local and national church meetings and conferences for many years. Their personal books were donated to the Amarillo United Citizens Forum library. (Courtesy of Lola Whitaker.)

Clemon (left) and Lola Whitaker were master of ceremonies and committee chair, respectively, for the Carter Chapel CME Church 100th celebration service. The celebration included a Saturday evening recognition banquet where longtime church members were honored for extensive years of faithful service and dedication to the church and community. (Courtesy of Lola Whitaker.)

Valarie Clarice Austin served Carter Chapel CME Church in various capacities as a longtime member. Her daughters, Bobbie (left) and Valarie Austin, guests at the 100th church celebration, are shown here. They were members of neighboring Mount Zion Missionary Baptist Church with their father, local mortician Clifford Austin. (Courtesy of Lola Whitaker.)

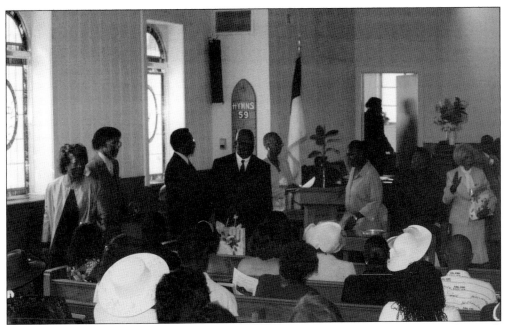

Pictured are honorees, community guests, and congregation members in attendance at the 100th church celebration at Carter Chapel CME Church. The picture shows the Christian flag and the stained-glass windows, all of which, along with the American flag, were donated by Elnora and John Jackson. (Courtesy of Clemon Whitaker.)

Ruby Lewis has been a member of Carter Chapel for over 70 years and is designated as the "Mother of the Church." In addition to her noted accomplishments in radio, she has also been involved with Habitat for Humanity, the American Red Cross, and the Amarillo United Citizens Forum, serving as president and on the Public Affairs Committee. She is the community press secretary for local and statewide news. At age 86, Ruby Lewis participated in the Senior Olympics and brought home the gold! (Courtesy of Clemon Whitaker.)

Lurketia Jones has attended Carter Chapel for over 30 years. Her service to the church includes announcing clerk, Women's Missionary Society, Sunday school, stewardesses, and Christian Youth Fellowship. Lurketia volunteers with the church in feeding the hungry each year and participates in the canned food, sock, and coat drives. (Courtesy of Lola Whitaker.)

Joyce Williams has been the church secretary for 15-plus years. Outside of Carter Chapel CME Church, she volunteers at the Tyler Resource Center of Amarillo, feeding the hungry during Thanksgiving and collecting socks and jeans for the clothes closet. She is also a participant in the annual Beans and Cornbread luncheon to raise funds for the homeless. (Courtesy of Lola Whitaker.)

Lola Whitaker (left) was the mistress of ceremonies for Carter Chapel's 100th church celebration recognition banquet. She joined Carter Chapel in 1954 and is an active choir member and stewardess. She is pictured with honorees and fellow longtime members Elliott Mann (center) and Joyce Williams (right). Lola Whitaker taught at Carver School as a reading specialist and was also the language arts coordinator. Later, as the principal of Robert E. Lee Elementary School, she was the first African American female in that position in the Amarillo Independent School District. Whitaker's community involvement includes Habitat for Humanity, the United Way, the Salvation Army, the Amarillo United Citizens Forum, the NAACP (life member), and Delta Sigma Theta Sorority, Inc. (Courtesy of Clemon Whitaker.)

Gloria Foster-Young is a longtime member of Carter Chapel CME Church. She was born in Amarillo and graduated from Carver and Amarillo Junior College. She completed her education at Fisk University in Nashville, Tennessee. She sang professionally with the renown Jubilee Singers and traveled with the group all over the world. Gloria taught at Carver High School as the director of music. Her talents also include playing the organ, pipe organ, and piano. She was a student of the illustrious Kathryn Hines. (Courtesy of Lola Whitaker.)

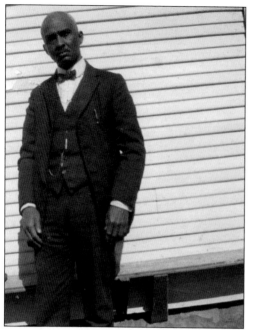

Johnson Chapel African Methodist Episcopal Church was organized in 1927 in the home of Mrs. Owens by the following members: Professor and Mrs. S. C. Patten, Mrs. Owens, Carrie Barrett, Mr. Marshall, Mr. and Mrs. Monroe Johnson, and Willie Hickman. The first church was called Patten Chapel. Prof. S. C. Patten served as the first pastor. Later it was renamed Johnson Chapel AME Church after Bishop W. D. Johnson when it was accepted in the Northwest Texas Conference. At the annual conference in 1928, Bishop J. Samson Brooks appointed Rev. J. M. Bolden as the second pastor of Johnson Chapel AME Church. The annex of the Presbyterian church located at Tenth Avenue and Taylor Street was purchased from ? Sanford and moved to 1901 North Washington Street, the present location, as the first church structure. ? Bivins donated the lot for the parsonage in 1945. (Courtesy of Flournoy Coble.)

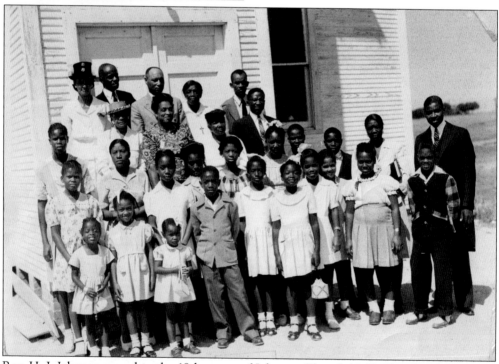

Rev. H. J. Johnson served as the 18th pastor of Johnson Chapel AME Church. The African Methodist Episcopal Church was founded by Richard Allen when he and others of African descent were denied the freedom to worship God in St. George's Methodist Episcopal Church in Philadelphia, Pennsylvania, in 1787. Pictured here are members of Johnson Chapel AME Church in 1945, including Rev. H. J. Johnson, Marion Cherry, Lola Plant, Willie Hickman, Mrs. S. C. Patten (Clara), and Vivian Bryant. (Courtesy of Flournoy Coble.)

Pictured are Rev. H. J. Johnson (second row, third from right) and the Usher Board, which included, from left to right in the second row, Edna Henderson, unidentified, Robbie Henderson, Kay Frances Wilson, and Marion Wilson. The duties of the Usher Board are to maintain the orderly flow of the service and stand at the entrances to allow the congregation to enter at the appointed times. (Courtesy of Flournoy Coble.)

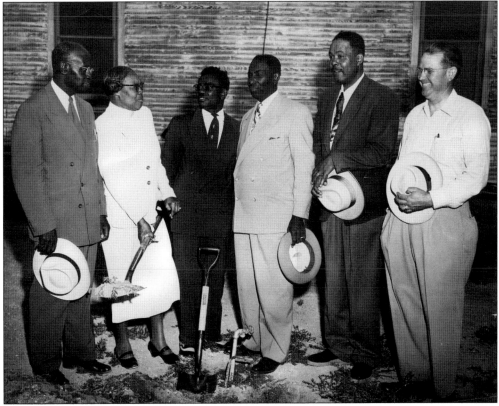

Rev. Inez Z. Chance was the 20th pastor of Johnson Chapel AME Church and served from 1947 to 1960, retiring in 1961. Here she is breaking ground for the parsonage in 1949 along with the support of, from left to right, Reverends J. W. Wade, B. W. Lockett, and F. N. Marshburn, Dr. J. O. Wyatt, and contractor M. B. Allen. (Courtesy of Johnson Chapel AME Church.)

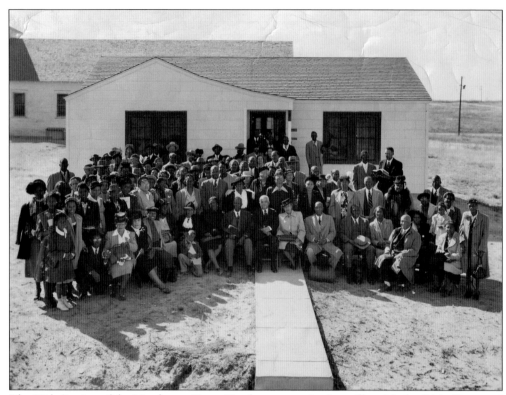

The 29th Session of the Northwest Texas Conference met in Amarillo with the Right Reverend Joseph Gomez, presiding bishop, Rev. J. L. Johnson, presiding elder, and Rev. I. Z. Chance, pastor; all are pictured with the congregation during the dedication of the parsonage. Since the AME Church is a connectional church, it was normal procedure for the conferences to move around to the various churches throughout the 10th Episcopal District of Texas. (Courtesy of Johnson Chapel AME Church.)

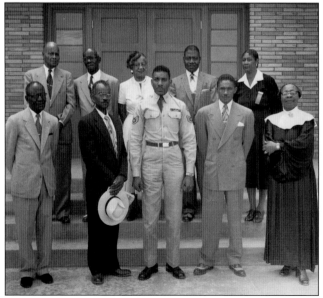

The Steward Board shown with Rev. I. Z. Chance (right, first row) included, from left to right, (first row) Cherry, Hickman, McCloney, and Anderson; (second row) Knapp, A. V. Jones, Hattie M. Moore, Jackson, and F. Anderson. Steward duties include seeking the needy and distressed in order to relieve and comfort them; making accurate reports of monetary expenditures, whether for the pastor, church, sick, or poor; and recording all baptisms, marriages, and deaths within the congregation. (Courtesy of Johnson Chapel AME Church.)

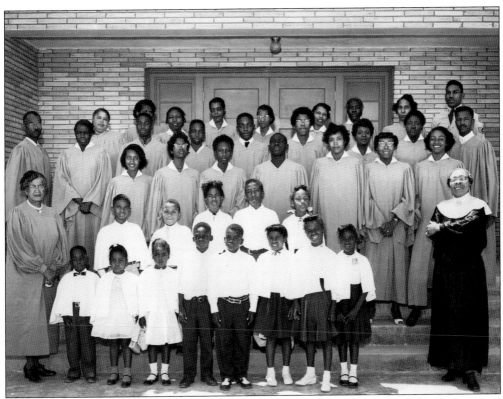

Johnson Chapel Choir and the Youth Choir are integral ministries in the AME church, governed by the rules of worship found in the *Doctrine and Discipline of the AME Church*. They should be regulated by strict rules, including the obligation to practice regularly and adhere to the Connectional Music Committee's bylaws where feasible. These were the choir members with Rev. I. Z. Chance on the steps of Johnson Chapel AME Church. (Courtesy of Johnson Chapel AME Church.)

The members of the church auxiliary of Johnson Chapel AME Church included, from left to right, (first row) Lorraine Martin, Annette Reynolds, Rosetta Calhoun, Jewelle Allen; (second row) Thelma Jackson, Emma Bradley, Elnora Woolbright, and Beulah Moore. Rev. I. Z. Chance is at right. In the AME Church, the pastor is the official head of all boards and auxiliaries and no change in their composition shall be considered legal without his or her consent and cooperation. All boards and auxiliaries are amenable to the Quarterly Conference. (Courtesy of Flournoy Coble.)

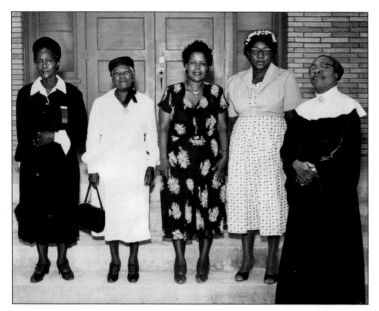

The Pastor's Aide Society cares for the needs of the pastor. The society included, along with Rev. Inez Z. Chance (right), (from left to right) Sisters Minnie Rose, Clara Patten, ? Weekly, and Cora Jones. They met regularly to maintain ministerial comforts and support within the church and were faithful and dutiful to their charge. (Courtesy of Flournoy Coble.)

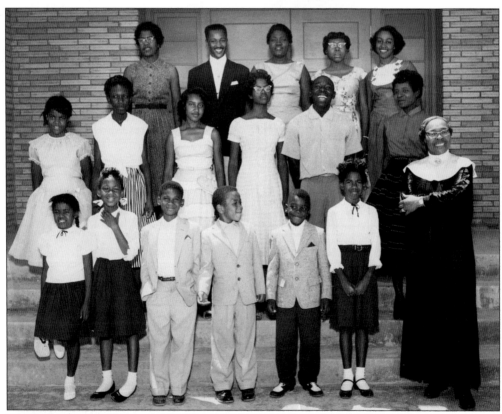

The Young People's Division of the Women's Missionary Society is always the future of any church and a very important ministry. It provides spiritual guidance for young people ranging in age from 2 to 17 along with good Christian activities and support. Members were pictured here with Rev. I. Z. Chance. (Courtesy of Johnson Chapel AME Church.)

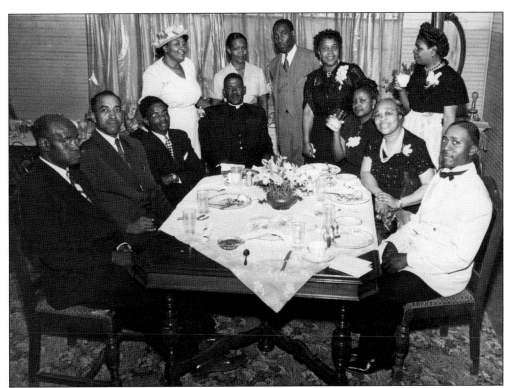

It was important for Reverend Chance to meet with various members of the community, and these ministers and their wives dined with her. Rev. I. Z. Chance was the first African American female minister and pastor in Amarillo, serving at Johnson Chapel AME Church from 1947 to 1960. The sanctuary of the church was dedicated July 15, 1956, and in 1966, the new educational building was erected, along with the parking area. The presiding bishop, the Right Reverend O. L. Sherman, dedicated the new structure on October 8, 1967. (Courtesy of Flournoy Coble.)

Members of the Usher Board of Johnson Chapel AME Church, along with Rev. I. Z. Chance, included, from left to right, (first row) Sisters Emma Bradley, Fannie Anderson, and Minnie Rose; (second row) Alva Baughman, Claude Hendricks, and unidentified. The Usher Board was always a very active auxiliary and greeted the public as they entered the sanctuary. The motto of Johnson Chapel AME Church is "Enter to Worship and Depart to Serve." (Courtesy of Flournoy Coble.)

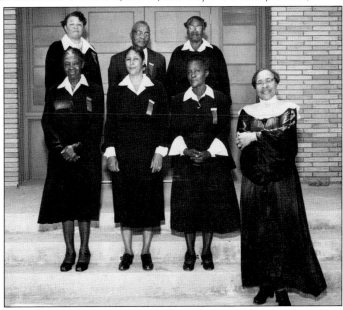

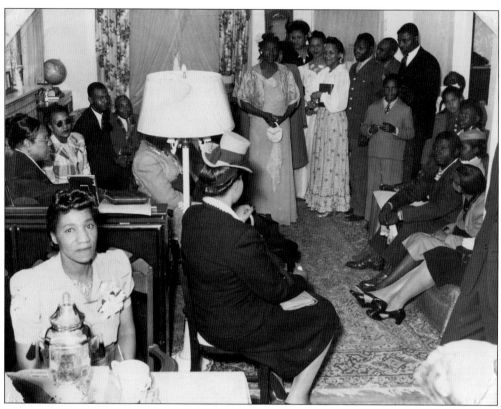

Pictured are members of Johnson Chapel AME Church attending a church social. The church was in the pivotal position in the African American community to host various meetings and conferences in addition to the regularly scheduled church services. Johnson Chapel was no different. Many NAACP meetings and cultural activities were held in the church in the early part of the 20th century. This was particularly true during the civil rights movement. (Courtesy of Johnson Chapel AME Church.)

The church in the African American community served as a vital part of the community in bringing families together to worship the Lord and take fellowship with one another. The ministers provided the leadership for not only their congregation but the community at large. Thus oftentimes it was the meeting place for other clubs and organizations in the community. (Courtesy of Johnson Chapel AME Church.)

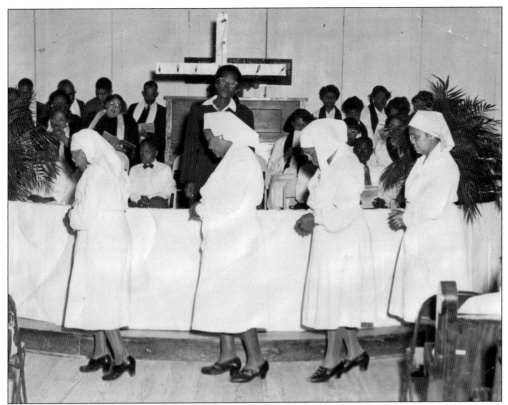

It is the duty of the stewardesses to assist the pastor and stewards in the ritual of the Lord's Supper. Here members of the Stewardess Board prepare for Holy Communion in the sanctuary of Johnson Chapel AME Church. Included are, from left to right, Sisters ? Young, ? Robinson, ? Tillie, and Clara Patten. Minnie Rose is standing in the center. (Courtesy of Johnson Chapel AME Church.)

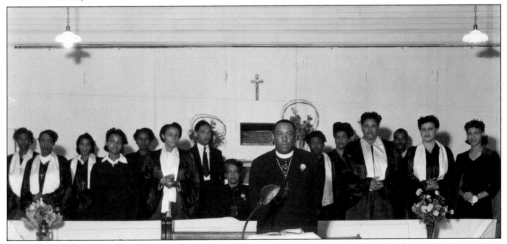

Rev. C. C. Brock was the 17th pastor of Johnson Chapel AME Church, from 1940 to 1944. Members of the Gospel and Senior Choir under the leadership of Reverend Brock were Buster and Lula Alexander, Edna Henderson, Josephine Warford, Nellie Wilson, Willie Hickman, Annette Reynolds, and others. (Courtesy of Flournoy Coble.)

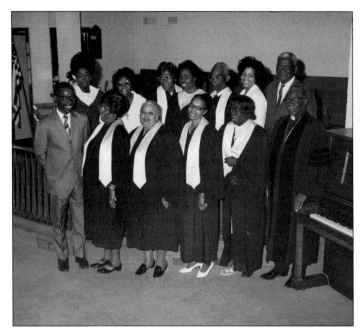

Rev. A. J. Davis was the 22nd pastor of Johnson Chapel AME Church. The members of the Gospel and Senior Choirs who served under his leadership were, from left to right, (first row) Buster and Lula Alexander, Beulah Moore, Thelma Sirles, Emma Bradley, and Reverend Davis; (second row) Edna Henderson Manning, Cora Bell Jones, Nellie Wilson, Bessie Terry, Willie Hickman, Annette Reynolds, and E. Manning. (Courtesy of Johnson Chapel AME Church.)

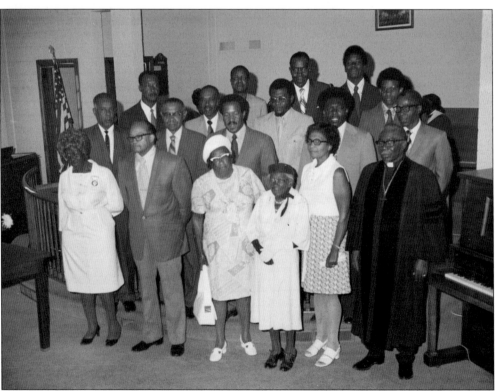

Members of the Steward and Trustee Boards who served under the leadership of Reverend Davis included Jewelle Allen, Clara Patten, Vivian Bryant, Benny Nevels, Emma Bradley, Lorenzo Jordan, Arthur Champion, Ernest Jones, Robert Manning, Buster Alexander, James Green, Charlie Wilson, Nathaniel Neal, and David Manning. (Courtesy of Johnson Chapel AME Church.)

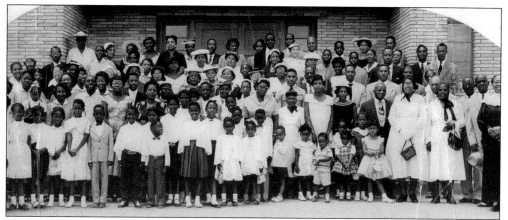

The Johnson Chapel AME Church family, shown here on the steps of the church, was representative of the African American community. The membership was made up of people from various walks of life, including businessmen and women, professors, principals and educators, a bailiff and lawmakers, military personnel and beauticians, coaches, truck drivers, housekeepers, cooks, clerks and railroad workers, musicians, singers, homemakers, seamstresses, nurses, engineers, and students. Families believed in the Lord, hard work, and education. (Courtesy of Johnson Chapel AME Church.)

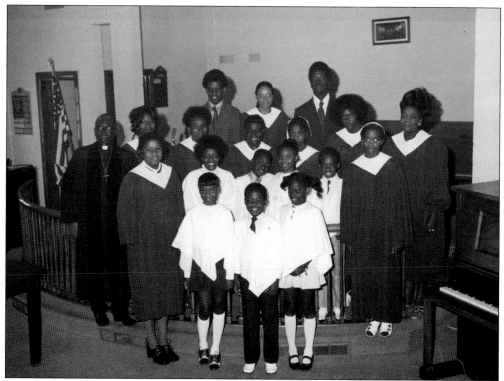

Members of the Youth Choir who served under Reverend Davis included Edna Manning (choir director), David Manning, Jackie Manning, Donna Neal, and Elizabeth Alexander. This choir provided music and hymns on the traditional day for youth services, the fourth Sunday of each month. The Johnson Chapel Youth Choir also traveled to other churches, carrying their ministry through music for youth programs and celebrations. (Courtesy of Helen Neal.)

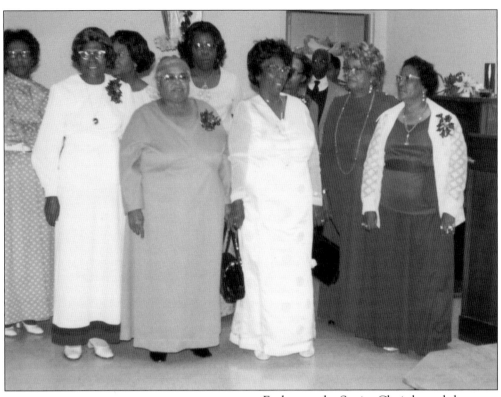

Each year, the Senior Choir hosted the Annual Christmas Tea for the community and congregation. They would sing joyous hymns and songs of the season and serve refreshments as they fellowshipped with members of the church and the community. Often the invited churches would render selections for the occasion. Members of the Senior Choir included, from left to right, Nada Anderson, Nellie Wilson, Peggy Crawford, Josephine Warford, Cora Jones, Lula Alexander, unidentified, and Flournoy Coble. (Courtesy of Helen Neal.)

Rev. Lloyd Chenault was the 27th pastor of Johnson Chapel AME Church. He was the spiritual leader of the congregation, with a penchant for cleanliness. He wanted a spotless church and would take to cleaning it himself if necessary. His family would help also. He especially enjoyed the commercial kitchen and would cook whole meals for the congregation and for church meetings and conferences. His wife, Thelma Chenault, had the voice of a songbird. (Courtesy of Helen Neal.)

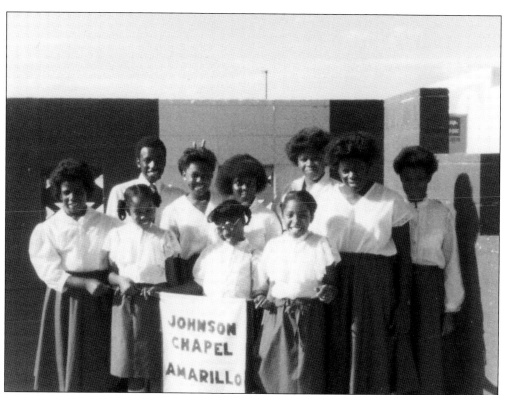

The Youth Choir in 1984 included Nikki Ruffin, Diane Thompson, Tonya Alexander, Dwayne Alexander, Kim Ruffin, Diane Jones, Cheyenne Thompson, and Vicki Thompson. They always looked nice in their crisp white blouses and dark skirts for the young ladies and white shirts with dark pants for the young man. (Courtesy of Helen Neal.)

Phillip Cody Randle is a lifelong member of Johnson Chapel who was raised in Amarillo. He graduated from Paul Quinn College in Waco and later returned to Amarillo, where he married the former Elizabeth Parrish and started his family. His older brother, William, was also raised in the church and resides in Amarillo with his wife, Carlotta. (Courtesy of Elizabeth Randle.)

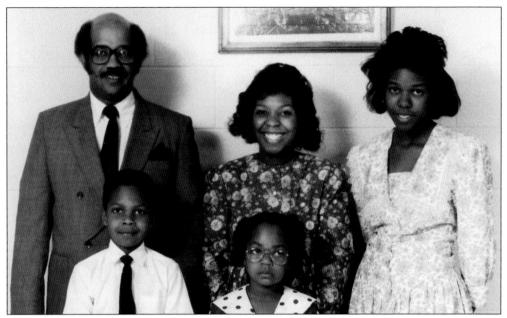

Rev. Phillip Randle became the 28th pastor of Johnson Chapel AME Church with his appointment in 1988. He is the longest serving pastor, with 20 years of service. He celebrated his 20th anniversary in 2008. It is customary in the AME Church to have pastoral appointments made each year by the presiding bishop. Reverend Randle is shown with his family: (first row) Brandon and April; (second row) Elizabeth and Jessica Harris. Under his leadership during the Conference Year 1992–1993, the church installed beautiful stained-glass windows in the sanctuary and siding on the parsonage. Since then, other improvements have been made in new heating and cooling systems, a public address system, handicapped accommodations, and interior painting. (Courtesy of Johnson Chapel AME Church.)

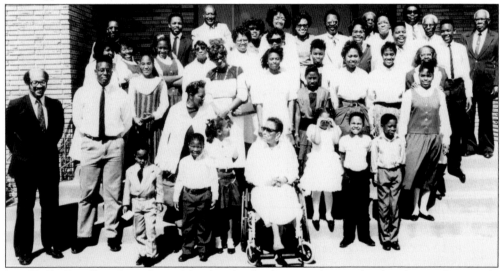

Rev. Phillip Randle and members of the church school are standing on the church steps. Frequently the church school had 100-percent participation. It was organized to run with the school year, and teachers met to coordinate the classroom schedules and curriculum. Nathaniel Neal, the church school superintendent, provided the necessary structure. In the summers, during vacation Bible school, the members saluted the American flag, Texas flag, and Christian flag. (Courtesy of Helen Neal.)

Members of the Junior Usher Board assisted the members of the Usher Board, particularly on Youth Sunday. Youth Sunday was each fourth Sunday, and the youth led the Sunday morning services. This involved leading the order of service, providing a youth speaker, and assisting the stewards with the collection of tithes and offerings. The members were, from left to right, Ramona Hood, Farrah Stuart, Nikki Ruffin, and Kia Taylor. (Courtesy of Helen Neal.)

The members of the Steward Board under the leadership of Reverend Randle included, from left to right, (first row) Buster Alexander, Dewey Sirles, Claudia Stuart, and Bessie Terry; (second row) Delores Thompson, Sharon Johnson, Charlie Wilson, and John Taylor. The Steward Board provides the spiritual leadership and oversight of the church. They maintain the church records of births, deaths, marriages, and membership and are accountable for the church finances and reports due to the 10th Episcopal District of Texas. They serve for one year at the behest of the pastor and often are reappointed each year the pastor serves. This board has been in place since Reverend Randle was appointed to Johnson Chapel AME Church by the bishop. The steward pro tem was Buster Alexander. (Courtesy of Helen Neal.)

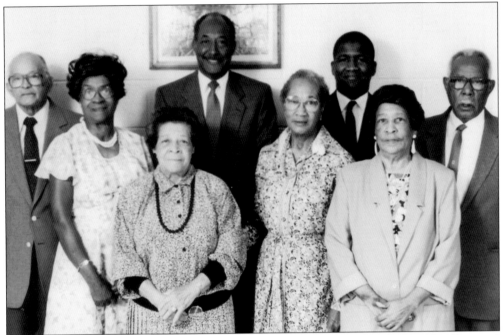

The members of the Trustee Board under Reverend Randle included, from left to right, (first row) Louise Yancey, Josephine Randle, Peggy Crawford, and Flournoy Coble; (second row) Benny Nevels (president), Nathaniel Neal, James Allen, and Lorenzo Jordan. The Trustee Board is responsible for the church facilities and maintaining the grounds and other property, including vehicles. They serve for one year at the behest of the pastor. (Courtesy of Helen Neal.)

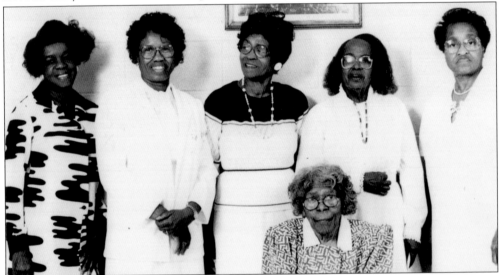

The members of the Women's Missionary Society under the leadership of Reverend Randle included, from left to right, Velma Ragsdale, Dorothy Sirles, Louise Yancey, Connie Jordan, Helen Neal, and (seated) Nellie Wilson. This church ministry provides spiritual direction, prayers, and support to the members as well as the community. Community service is very important to this body in spreading the Gospel to others and supporting various community projects and service agencies. (Courtesy of Johnson Chapel AME Church.)

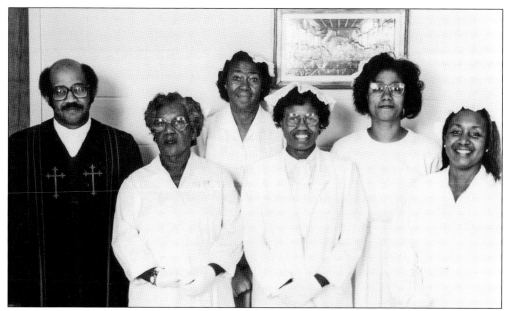

The members of the Stewardess Board along with Rev. Phillip Randle included, from left to right, Ruth Alexander, Fredericka Harvey, Dorothy Sirles, Sharon Johnson, and Merylen Davis. The board assists with Holy Communion for the church body and provides a special program at Johnson Chapel on fifth Sundays. (Courtesy of Johnson Chapel AME Church.)

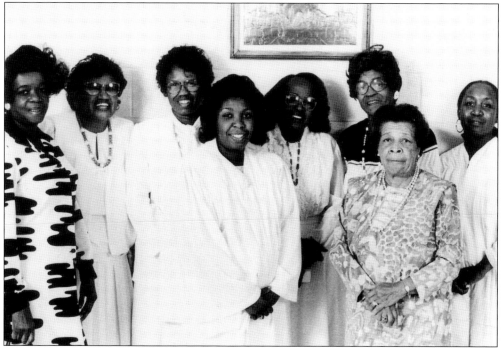

Pictured here are, from left to right, members of the Women's Missionary Society: Velma Ragsdale, unidentified, Dorothy Sirles, Elizabeth Randle, Connie Jordan, Louise Yancey, Josephine Randle, and Merylen Davis. The Connectional Motto for the AME Church worldwide is "God our Father, Christ our Redeemer, and Man our Brother." (Courtesy of Johnson Chapel AME Church.)

Members of the Chapel Choir missing in the picture on the facing page are Claudia Stuart (left) and Ann Perry (below). The Chapel Choir was directed by several former musicians through the years. They included very talented and spiritual musicians well respected throughout the community. Among the directors were Winnie Jones, Edna Manning, Rick Jones, and Donnell Hill. Though Donnell Hill served as the musician and choir director at his father's church at New Hope Baptist Church, he served at Johnson Chapel as well. Donnell Hill also directed the Hood Mass Choir, which provided melodious songs during the Christmas holidays throughout the community and in various venues, including churches, community centers, schools, colleges and universities, and the Amarillo Civic Center. (Courtesy of Johnson Chapel AME Church.)

The members of the Chapel Choir pictured with Rev. Phillip Randle (left) include Delores Thompson (second from left) and, from left to right, (first row) Merylen Davis, Josephine Randle, and Flournoy Coble; (second row) Bessie Terry, Ellen Bland, Jimmie Mallory, Peggy Crawford, and Roushell Hamilton. (Courtesy of Johnson Chapel AME Church.)

The Young Adults Ministry of Johnson Chapel included, from left to right, (first row) Elizabeth Randle, Farrah Stuart, and Angela Allen; (second row) Jessica Parrish, Kim Ruffin, and Gussie Whitaker; (third row) Kia Taylor, Jay Whitaker, and Ramon Diggs. These young people will carry on the banner for the AME Church for years to come. (Courtesy of Johnson Chapel AME Church.)

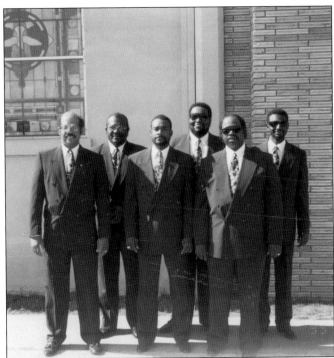

The members of the Johnson Chapel Men's Choir under Reverend Randle (left) provided spirit-filled services on the third Sunday of each month. The members included, from left to right, Lorenzo Woodberry, Tony Gindratt, Roushell Hamilton, Anthony Phil Jones, and David Jones. Tony Gindratt also served as the superintendent of the church school and on the Steward Board along with Lorenzo Woodberry, Roushell Hamilton, and David Jones. (Courtesy of Helen Neal.)

Members of the Junior Steward Board are trained early to take on the role and responsibility of stewards. They shadow the stewards and learn their role as prescribed in the *Doctrine and Discipline*. The members included, from left to right, Vincent Brown, Kim Ruffin, and Delaware Jones. (Courtesy of Johnson Chapel AME Church.)

Members of the senior class in the church school meet each Sunday morning to fellowship and study the Word through scriptures and the lessons. The senior class included, from left to right, Jimmie Britten, Thelma Jackson, Charlotte Green, Helen Neal, and Buster Alexander. (Courtesy of Johnson Chapel AME Church.)

Members of the Senior Choir and Chapel Choir sponsor the Christmas Tea for members of Johnson Chapel and the community. They render many holiday songs and remember to keep Christ in Christmas. Other churches are invited to participate in songs and fellowship. Those pictured include Bessie Terry, Josephine Randle, Delores Thompson, Claudia Stuart, Flournoy Coble, Ellen Bland, Peggy Crawford, Buster Alexander, Merylen Davis, and Gloria Roberts. (Courtesy of Johnson Chapel AME Church.)

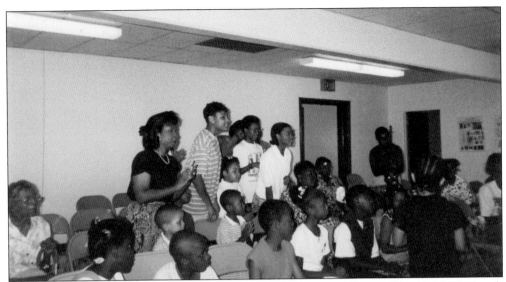

Young people and church members alike gather each summer at Johnson Chapel AME Church for vacation Bible school. This is led by the director of Christian education, Angela Allen, and the students salute the American flag, Texas flag, and Christian flag each day of VBS. There are many arts and crafts to be made and fun to be had while learning the message of the Gospel. (Courtesy of Johnson Chapel AME Church.)

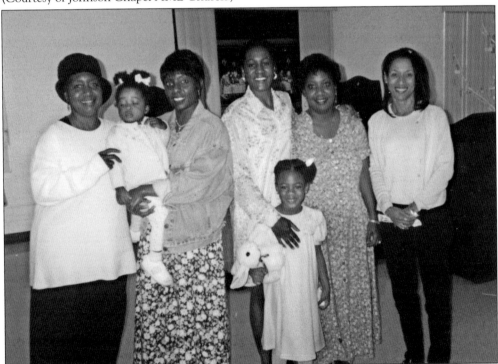

Members of Johnson Chapel gather often in the Fellowship Hall for various celebrations. After the Easter program, those shown here are, from left to right, Merylen Davis, Sydney Wilson, Lisa Cherry, Farrah Stuart, Raquelle Lawrence, Angela Allen, and Cherie Wilson. (Courtesy of Johnson Chapel AME Church.)

Each year, the church school sponsors the Easter Egg Fellowship, with the youth hunting eggs in Bones Hooks Park. On occasion, snow would prevent the egg hunt, and all would be moved inside the Fellowship Hall. Later in the evening, the youth would participate in the Easter Program with speeches and hymns. Members shown here are, from left to right, Kim Ruffin, Diane Thompson, Vicki Thompson, Cheyenne Thompson, Dietra Stuart, and Farrah Stuart (in front). (Courtesy of Johnson Chapel AME Church.)

Each summer, Johnson Chapel has a grand church picnic in Thompson Park. Many members gather to fellowship with fun, food, and games. Young and old enjoy themselves and look forward to the next year. The event is usually catered, and members delight in the good food and desserts. Youth also enjoy a walk through the Amarillo Zoo and Wonderland Park. Members shown here include Frederica Harvey, Jimmie Britten, Josephine Randle, Gloria Roberts, Flornoy Coble, Allison Roberts, Peggy Crawford, and Thelma Jackson. (Courtesy of Johnson Chapel AME Church.)

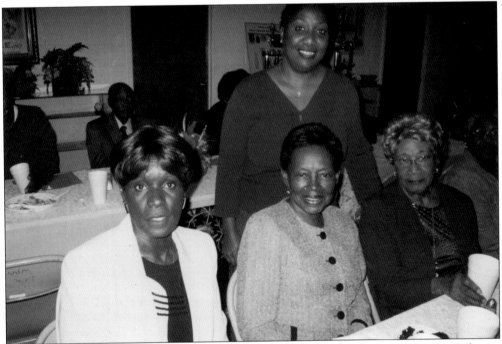

Church banquets are occasions to fellowship and eat the fine food prepared by the Culinary Ministry. Johnson Chapel participates in many community programs, food banks, and homeless shelter programs and has a Prison Ministry at the Nathaniel Neal Unit of the women's prison. This prison unit was named for longtime church member Nathaniel Neal. Members of Johnson Chapel shown are Angela Allen (standing), Betty Hood (left), Nellie Sherwood (center), and Peggy Crawford (right). (Courtesy of Johnson Chapel AME Church.)

The church banquet is a time to invite others into the celebration and have a great time in the Lord. Claudia Stuart serves in various capacities at the church as steward pro tem, Chapel Choir member, announcing clerk, and church school member. As a delegate, she participates in the various AME Connectional Church meetings in Texas and throughout the United States. (Courtesy of Johnson Chapel AME Church.)

The church banquet is successful because of the Culinary Ministry headed by Gussie Whitaker and Linn Turner. These talented ladies put the menus together for church functions, funerals, and other events. Gussie Whitaker also serves as a trustee and Chapel Choir member and teaches a youth class in church school. (Courtesy of Johnson Chapel AME Church.)

The Culinary Ministry is headed by Gussie Whitaker. She was the first African American licensed butcher in Amarillo and worked for many years at Safeway and Edes Meats. She has certainly put her special skills to work at Johnson Chapel, and her desserts and rolls are legendary. Other auxiliaries assist with this ministry in order to enhance good food, good service, and good fellowship. (Courtesy of Johnson Chapel AME Church.)

The Johnson Chapel AME Church School would sponsor the Church School Convention for the Northwest Texas Conference at Ceta Canyon. This was always a wonderful place to hold the convention because of the space and beautiful surroundings. AME members would come from all over the Texas Panhandle and the Dallas/Fort Worth Metroplex to attend. The members here are, from left to right, Danielle Chapman, Shonta Major, Alexis Hunter, TeAntae Sargent, and Chantel Harris. (Courtesy of Johnson Chapel AME Church.)

Members of Johnson Chapel support the Race for the Cure and afterward meet back at the church to fellowship with one another. Shown are, from left to right, Thelma Jackson, Charlotte Green, and Buster Alexander. (Courtesy of Johnson Chapel AME Church.)

The sanctuary of Johnson Chapel is adorned with beautiful stained-glass windows depicting the Trinity. The members of the congregation sponsored the campaign for the windows under the leadership of Rev. Phillip Randle. Those gathered included, from left to right, Tommie Hamilton, Theresa Perry, Gussie Whitaker, and Brooke Nickerson. (Courtesy of Johnson Chapel AME Church.)

The Fellowship Hall of Johnson Chapel was dedicated to the memory of Nathaniel Neal and Lorenzo Jordan. Present for the celebration were four generations of the Neal family, including, from left to right, (first row) Delores Thompson, Gloria Roberts, Helen Neal, Joshua Whitley (in Helen's lap), and Kim Whitley; (second row) Michael Whitley, Nathan Roberts, Allison Roberts, and Allen Roberts. (Courtesy of Johnson Chapel AME Church.)

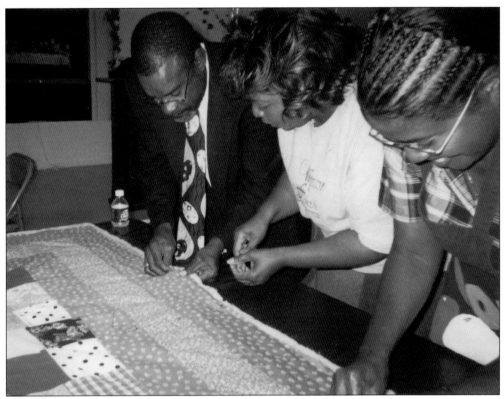

Johnson Chapel has a Quilting Ministry headed by Helen Neal. Members usually meet on Saturdays in the Fellowship Hall to make quilts of varying fabrics, colors, and designs. Helen Neal has presented this program to many community organizations and has taught many the art of quilting. Those pictured include, from left to right, Tony Gindratt, Elizabeth Randle, and Claudia Stuart. Other members are Delores Thompson, Gussie Whitaker, and Merylen Davis. Many members, families, and friends have been recipients of the quilts and include them as their most cherished possessions. (Courtesy of Johnson Chapel AME Church.)

Rev. J. W. Wade and the first lady of Jenkins Chapel, Eva Wade, came to Jenkins Chapel in 1946. Serving with Reverend Wade at the time were Delma Ward, chairman of the Deacon Board; Frank Knighton, chairman of the Trustee Board; Billie Jo Cooks, secretary; Thelma Tallie, church clerk; and Alexander Hazelrigg, treasurer. (Courtesy of James Vell McGhee.)

Rev. Cleason Frost, married to Joyce Nickerson Frost, was from Amarillo and was first called to preach at a church in Hereford, Texas. There are five children from that union: Cleaster, Glenn, Cleason Jr., Louzene, and Anazene. Frost served at Jenkins Chapel Baptist Church for 15 years, first as assistant pastor to Reverend Wade in 1979 and as interim pastor in 1980; he was called as the pastor in 1981. Reverend Frost was very active in the Interdenominational Ministerial Alliance and served as Zone 3 chairman of the Original West Texas Baptist District. A truly warm-hearted person, he would strive to assist others in any way he could. (Courtesy of Pearlene Martin.)

Pictured are Rev. Cleason L. Frost; the first lady of Jenkins Chapel, Joyce Frost (center); and Novella Spencer. Reverend Frost was from Ida Bell, Oklahoma. Joyce Frost, from Amarillo, and her brother O. D. Nickerson were longtime members of Jenkins Chapel. O. D. Nickerson was a building contractor in Amarillo with his own business. Reverend Frost served as pastor for 10 years. (Courtesy of Lillie Miller.)

Rev. Darrel Delaino Fincher came to Jenkins Chapel from Odessa, Texas, in 2004. He immediately became actively involved in the community and was later named president of the Ministerial Alliance. He has served as guest minister at various churches in the community and has a weekly radio program. (Courtesy of W. Jean McGhee.)

During the 82nd church anniversary, the first lady of the church, Jessie Fincher, walks down the aisle. Also pictured are members and guests seated in the congregation: from left to right, Grover Martin, Gus Harrison, Jackie Montague, and Rev. James Jackson. (Courtesy of W. Jean McGhee.)

During the 82nd church anniversary, Rev. D. D. Fincher (center) is pictured with James Vell and Willie Jean McGhee—the king and queen of the church celebration. Patrons were solicited from all over Amarillo in order to support other programs and activities of the church. King and queen hold court for one year. (Courtesy of Jenkins Chapel.)

Mr. and Mrs. James Vell McGhee are crowned as king and queen during the 82nd church anniversary celebration. This honor is the culmination of fund-raising through patronage leading up to the service at Jenkins Chapel Baptist Church. Many participate in this ceremony from throughout the community. (Courtesy of Jenkins Chapel.)

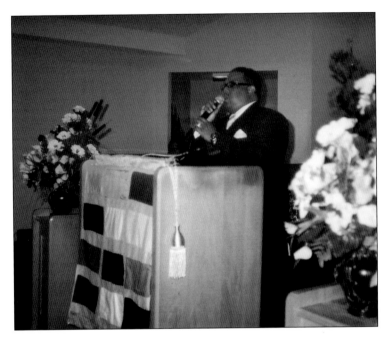

It is always moving and spiritually uplifting to have a minister render a hymn during the service or celebration. Here Rev. Darrel Delaino Fincher renders a hymn from the pulpit during the anniversary celebration. (Courtesy of W. Jean McGhee.)

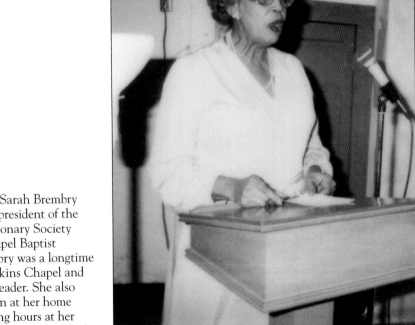

Shown here is Sarah Brembry serving as the president of the Women's Missionary Society of Jenkins Chapel Baptist Church. Brembry was a longtime member of Jenkins Chapel and a community leader. She also had a hair salon at her home and worked long hours at her craft. (Courtesy of Lillie Miller.)

Roger Scott was a longtime member of Jenkins Chapel Baptist Church and served as the chairman of the Deacon Board. He graduated from Carver High School, where, interestingly, he suffered a broken leg during the school's first football game. He later graduated from Texas College in Tyler. In the community, Roger Scott was the director of Upward Bound and Student Special Services at West Texas State University, later West Texas A&M University, until his retirement. He also served as president of the Amarillo branch of the NAACP and tackled many community concerns during his tenure. (Courtesy of Lillie Miller.)

Pictured here are longtime members of Jenkins Chapel Oscar Brown (left) and Delma Ward. Brown served as president of the Senior Choir for over 30 years. Ward was chairman of the Deacon Board. (Courtesy of Lillie Miller.)

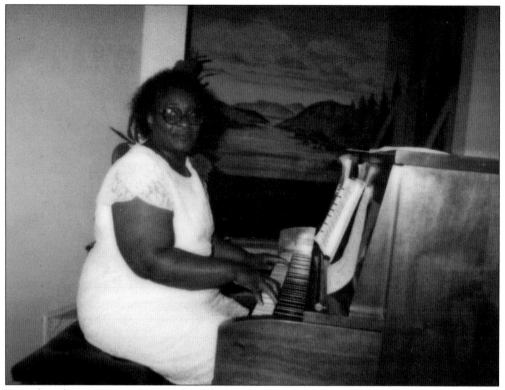

Seated at the piano is Lois Rowe Williams. She served Jenkins Chapel Baptist Church as a musician and as the intermediate class Sunday school teacher. She was also a longtime member of Delta Sigma Theta Sorority. (Courtesy of Lillie Miller.)

Pictured with the Men's Usher Board at Jenkins Chapel Baptist Church is Cellray Hamilton (center). Usher Board members are posted at the doors of the sanctuary during the worship service to facilitate the entry of the congregation in an orderly fashion. (Courtesy of Lillie Miller.)

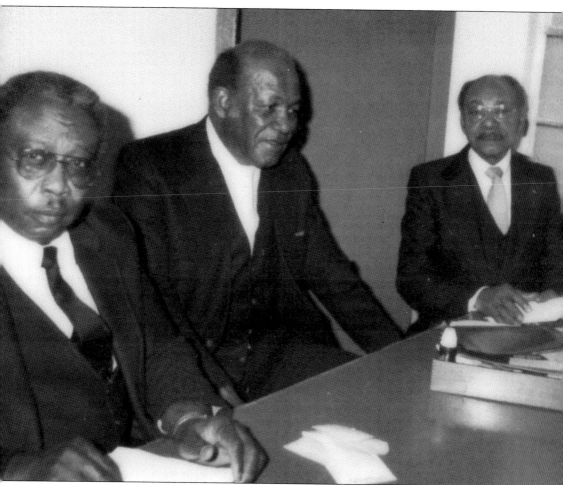

Pictured here is longtime Jenkins Chapel member Johnny Allen (center). Coach Allen was the head football coach at Carver High School for many years. He was known throughout the state of Texas for his legendary coaching abilities and championship teams. He later served as the cross-country coach for all four high schools in Amarillo. The Johnny Allen Elementary School was named in his honor. He was known by many youth in Amarillo as a strict educator and disciplinarian. (Courtesy of Lillie Miller.)

The Women's Missionary Society of Jenkins Chapel Baptist Church, with Jimmie Jones (sitting), president, gathered on the church steps. The Missionary Society takes care of sick members and prepares and delivers food to the shut in. Other community projects include quilts for area convalescence homes, food drives for the hungry, and donations of supplies and paper goods to the Tyler Street Resource Center in Amarillo. Baskets of food are provided for families in need during Thanksgiving and Christmas. (Courtesy of Jenkins Chapel.)

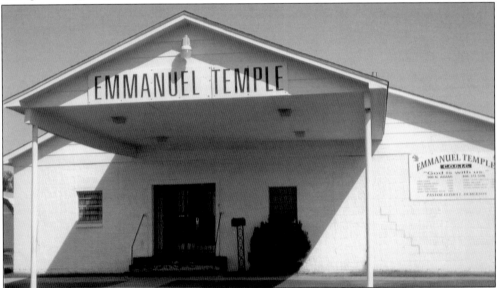

In 1951, Rev. H. W. Cortez founded Emmanuel Church of God in Christ. In 1995, under the leadership of Supt. Elisha Demerson, the name of the church was changed to Emmanuel Temple Church of God in Christ. In addition to the building pictured, there is a youth training center that accommodates an active youth program. The church focuses on young people, feeding the homeless, and a general outreach ministry in the community. (Courtesy of Elisha Demerson.)

Pictured is Brady Cortez, also known as B. D. He passed away in 1983 and was the eldest son of Rev. H. W. Cortez. Pictured with B. D. Cortez is his wife, Narline Cortez. She was known as the pillar of the church. (Courtesy of Elisha Demerson.)

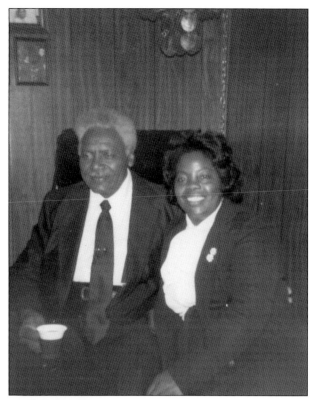

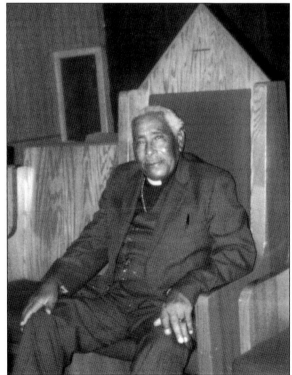

Rev. H. W. Cortez, founder of Emmanuel Church of God in Christ, lost his battle with cancer in 1987. His ministry spanned many years, and he had many faithful members in his congregation. He is pictured here at approximately 80 years old. (Courtesy of Elisha Demerson.)

Rev. H. W. Cortez is pictured with his wife, Thenelia, at a celebration. They founded Emmanuel Church of God in Christ together in 1951. She passed away in 1983, the same year as their son, Brady. The vision Rev. H. W. Cortez had for the church continued through his son Rev. Jesse Cortez and now through the current pastor, Supt. Elisha Demerson. (Courtesy of Elisha Demerson.)

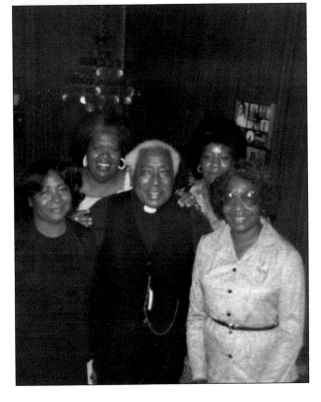

Rev. H. W. Cortez is pictured here with his daughters, from left to right: Opaline Thrower (third daughter), Nadine Johnson (second daughter), Daphine Hendry (youngest daughter), and Joni Edwards (eldest daughter). They had gathered in 1983 after the death of Thenelia, their mother, in order to pay respect and worship together. (Courtesy of Elisha Demerson.)

Rev. H. W. Cortez and his son, Elder Jesse Lee Cortez, are pictured here in 1985. Rev. Jesse Cortez came back to Amarillo in 1984 to assist in his father's ministry at the Emmanuel Church of God in Christ. He also organized and presided over Samaritans Outreach Ministries, Inc., providing food and clothing to the disadvantaged in the community. The Samaritans Outreach Ministries was located in the Tyler Resource Center in Amarillo. (Courtesy of Elisha Demerson.)

Rev. E. J. Cofer (third from left) was photographed in 1991 with, from left to right, Kenneth Bates, Minister R. B. Jeffrey, Minister Joe Taylor, Rev. Jesse Cortez, Br. Sam Edwards, and Br. Everett Ashley. Reverend Cortez and his deacons from Emmanuel Church of God in Christ served as advisors to Reverend Cofer when he founded New Birth Bible Fellowship Church in April 1999. New Birth is a nondenominational congregation with teachings taken directly from the Bible. (Courtesy of Joe Cofer.)

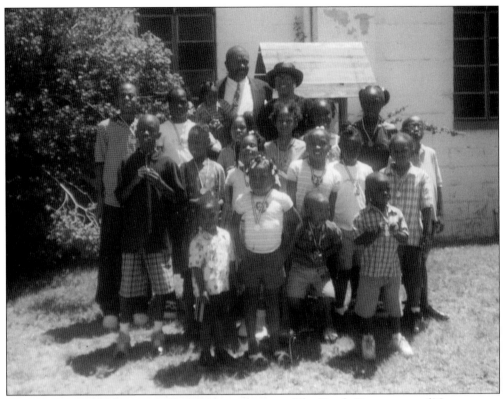

The Youth Department of New Birth Bible Fellowship is quite active. This picture depicts the youth participants of a 2003 church retreat that included two days of biblical teaching and games culminating in all attending Sunday school together. The children were even treated to a sleepover at the family home of their pastor. (Courtesy of Joe Cofer.)

Supt. Elisha Demerson serves as the senior pastor of Emmanuel Temple Church of God in Christ, Inc. The first lady of the church is Bobbie J. Demerson. Superintendent Demerson has been in the ministry in Amarillo since 1976. He also served as a Potter County commissioner and later ran a very successful campaign for Potter County judge. Elisha Demerson was the first African American county judge in the state of Texas. (Courtesy of Elisha Demerson.)

Pictured are Pastor Demerson and Bobbie Demerson at the 19th Annual Appreciation Service. Reflecting on the years of service, noted accomplishments include remodeling of the sanctuary, a new roof, new carpet and lighting, remodeling the restrooms, and the addition of the Fellowship Hall and classrooms. Extensive landscaping was also undertaken. Pastor Demerson has an identical twin brother, Pastor Elijah Demerson, who serves with his wife, Eartha, at the Pentecostal Church of God in Christ. Both pastors are tremendous spiritual leaders and are well known throughout the Amarillo community. (Courtesy of Elisha Demerson.)

Shown is Rev. David Hill Sr., pastor of New Hope Baptist Church. Rev. David Hill is a prominent minister in Amarillo who is very committed and involved in the community. He often takes his sermons to area churches and is also committed to resolving civil rights issues in the community. A longtime member of the NAACP, he has actively sought justice for citizens through the courts, schools, and social service agencies. He is a well-known and well-respected community leader. (Courtesy of Ella Shed.)

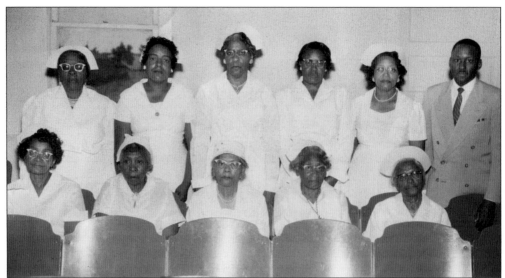

Rev. David Hill is pictured with members of his Deaconess Board in 1959. Members included Olivia Mitchell, Lorraine McLemore, Tula Green, and Pocahontas Brown. Reverend Hill is a community activist and is known for having spoken out against racial injustices during the civil rights movement. (Courtesy of Ella Shed.)

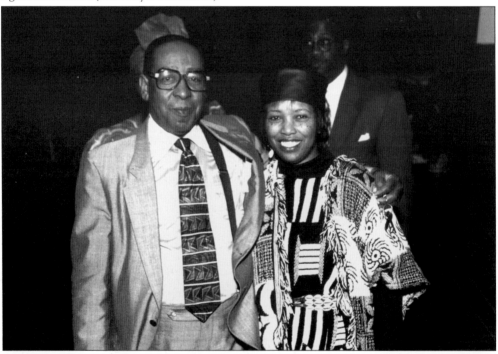

Pictured are Rev. V. P. Perry and Barbara Spencer Dunn in 1996. Reverend Perry was called to pastor Mount Olive Baptist Church. He was very active in the civil rights movement in Amarillo. As a community activist, he challenged many unfair practices and was an eloquent speaker on the rights of African Americans. Barbara Dunn is the daughter of Rev. Vernon Spencer, the founding pastor of Mount Olive Baptist Church. Barbara and her husband, Carl, currently reside in Maryland. (Courtesy of Claudia Stuart.)

Four

SCHOOLS
IN TIMES LIKE THESE

Pictured is the residence of the S. C. Patten family. This was a very prominent family in the black community, and they were very involved in the school and church. They helped in any way they could to lend their money, skills, talent, and intellect to enhance and better the community. The family later donated the home, and it became the building for the Patten High School. (Courtesy of Daniel Johnson.)

Prof. S. C. Patten owned one of the first vehicles in the community. This transported the family to many of their school and community commitments. They had moved into the area from Houston in order for Patten to teach school. In those days, since the community was so small, one knew all the children and where they resided. Keeping them in school was an easier task then, since schools were a pivotal part of the community and brought families together. All worked together and supported the child's ability to stay in school. (Courtesy of Daniel Johnson.)

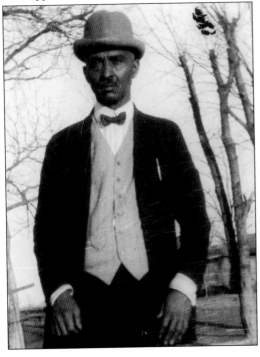

Prof. Silas C. Patten was a distinguished member of the Amarillo community. Known as Professor Patten, he was the principal at both the Frederick Douglass School (1925) and later at the school that bore his name, the S. C. Patten School (1928). Professor Patten also founded what became the Johnson Chapel AME Church and was its first pastor. (Courtesy of Daniel Johnson.)

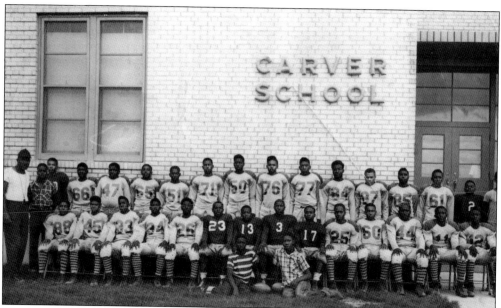

The 1949 Carver High School football team, with coach Johnnie Allen, included R. Smith (0), R. Anderson (2), J. Etherly (3), F. Anderson (11), C. Hooker (12), R. Anderson (13), J. Martin (17), W. Gholston (23), B. Bates (25), E. Johnson (26), J. Austin (33), H. Thrower (34), C. Williams (44), J. Davis (45), E. Smith (47), W. Pride (50), L. Mitchell (51), R. Mees (60), C. Jones (61), P. Young (65), W. Jones (66), A. Eddington (71), J. Quinton (76), R. Scott (77), J. McGhee (84), C. Holloman (85), J. Turner (87), Bill Young (88), managers V. Sanders (striped shirt) and G. White (front right), E. Mitchell (far right), and trainer L. McCoy (plaid shirt, left). (Courtesy of James Vell McGhee.)

The Carver faculty roster shows how many people got involved in educating the children of the community. The alumni agree that they had excellent teachers both in their academics and in their extracurricular activities. Students got as good an education as they would have gotten anywhere. (Courtesy of Jewelle Allen.)

CARVER FACULTY

Adamson, Frances	Jefferson, Van T.
Alexander, Lula E.	Jones, Ernest
Allen, Edward H.	Johnson, Guthrie D.
Allen, Jewelle L.	Johnson, Mary H.
Allen, Johnny N.	Jones, Katherine
Ammons, William H.	Kelly, Iva B.
Anderson, Nada K.	Kemp, Allie M.
Antwine, Dorothy E.	Kite, Carolyn
Austin, Bobbye C.	Kollmar, Rosemary
Avery, Ike	Laney, Robert L.
Bailey, Bennye J.	Leezer, Sarah
Bailey, Jerry	Lewis, Irene
Benjamin, Johnny	Longbine, Pearl
Bilton, Martha	Mayes, Thelma D.
Blackburn, Greta Y.	McClinton, Anne
Bolden, Esther D.	McDonald, Jewel
Booker, Ruby D.	McCullough, Mildred
Brown, Edna H.	Mims, Sam
Brown, Jewell M.	Morgan, Calvin
Bryant, Vivian M.	Morgan, Rutheece
Bunch, Patsy	Myers, Juanita
Calhoun, Roselle H.	Martin, Pearlene G.
Campbell, Clara	McAlister, Theresa B.*
Champion, Lillian W.	Montague, Jackie L.
Chandler, Avis K.	Murren, Margaret
Chapman, Alyce G.	Nash, Jim L.
Coil, Charles M.	Neal, Nathaniel J.
Cormack, Annita	Neal, Susie F.
Cowens, Esther K.	Nickerson, Rose M.
Conner, James	Overston, Mary M.
Dixon, Jean V.	Person, Lorenza
Dutton, Richard	Phillips, Cora
Dutton, La Rue	Prescott, Carolyn
Elkins, Shirley J.	Pyatt, Reatha
Essary, Juanna J.	Rains, Jerry
Faine, Levarn L.	Raley, Charles
Faine, Nina W.	Reeder, Hazel
Foster, Gloria F.	Richardson, Gaynelle T.
Fuller, Lloyd E.	Robertson, Jo D.
George, Norma E.	Robinson, Lilly V.*
Gooden, Arvella J.	Rouse, James
Goodlow, Queen E.	Sadler, Patrick
Gray, Sherman D.	Sanders, Irene C.
Greene, Ira J.	Scott, Nella M.
Goree, Silas	Scott, Roger C.
Graves, Cornelia *	Small, Calvin
Hand, Mary J.	Smith, Edward L.
Harris, Julia	Smith, Tallie A.*
Henderson, Edwin B.	Smith, Virginia
Hensley, Elbert	Steele, Richard
Herbert, Delores *	Steinpreis, Sally
Herbert, John *	Stone, Mike
Hisbon, Billy M.	Stubblefield, Marie W.
Hisbon, Irma J.	Stubblefield, Johnny F.
Holleman, Martha	Turner, Mary J.
Holleman, Wiley, Jr.	Ward, Deborah
Hughes, Uline L.	Ward, Forrest
Isaacs, Barbara	Whitaker, Clemon
Jackson, Claudine B.	Whitaker, Lola
Jackson, Elnora V.	Whinnery, Virginia
Jackson, Thelma	Williams, Lawrence
Jefferson, Virene E.	Wilson, Willie A.
* Deceased	

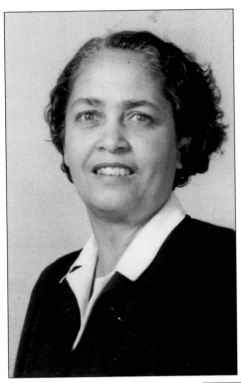

An important part of the school's administration was the nurse at Carver School, Pearl Longbine. Any time a student complained of aches and pains and was sent to the nurse, she would care for them and strive to keep them in school. Medical care was not something readily available to families who were not able to go to the hospitals because of segregation. (Courtesy of Jewelle Allen.)

Eloise Pearson (Jones) was the first football queen of Carver High School in 1949. From 1949 to 1958, the high school classes were taught at the Carver School at 707 North Hughes Street. Second- through sixth-grade classes were also taught in the school. George Washington Carver High opened its doors on Northwest Twelfth Street during the 1959–1960 school year. (Courtesy of Jewelle Allen.)

Judy Mitchell (Turner) was the last football queen of Carver High School. She was one of 69 students in the last graduating class of the school in 1967. She later graduated from West Texas State University, now known as West Texas A&M University. Integration had forced the closure of the black community's only high school. It then became a junior high school in the Amarillo Independent School District. It closed in 1973. The Carver Elementary Academy is currently located in the former Carver School building. (Courtesy of Jewelle Allen.)

James Vell McGhee was in the first graduating class of Carver School. He played on the football team that won the state championship in 1952. It was a joyous time for celebration, and that title brought much fame to the fighting Dragons of Carver High School with a perfect 7-0 record for the season. (Courtesy of James Vell McGhee.)

Racheal Jennings, a member of the Carver High School class of 1967, was presented as a debutante during the Debutante Ball and escorted by coach Johnny Allen. Racheal served in the National Honor Society. She later attended West Texas State University, now West Texas A&M University. (Courtesy of Jewelle Allen.)

Pictured is the Carver School Orchestra. Courtney Allen played bass fiddle under orchestra conductor Johnny Stubblefield in November 1958. This picture was taken at the Hughes Street campus before the new high school was built on Northwest Twelfth Street. (Courtesy of Jewelle Allen.)

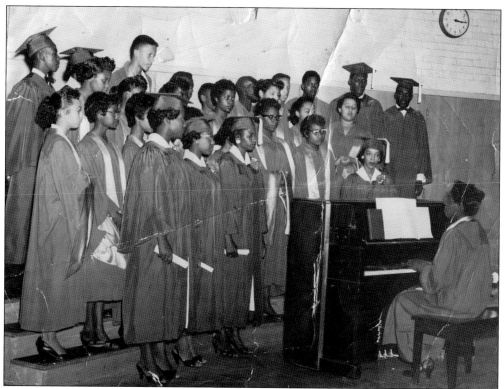

Pictured is the Carver School Choir in 1956 at the Hughes Street campus. Here they are practicing for their graduation ceremony accompanied by their director, Gloria Foster. Gloria Foster, later known as Gloria Foster-Young, is a very accomplished musician and often lends her talents to community events and programs. (Courtesy of Jewelle Allen.)

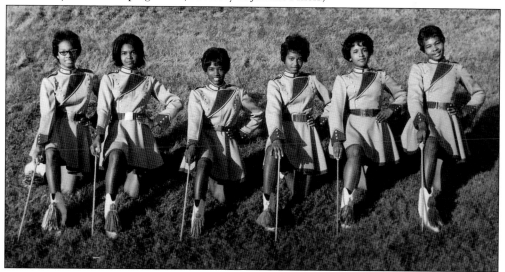

Carver High School majorettes were, from left to right, are Janet Williams, Jacqueline Askew, Frances Spencer, Johnnie Delores Griffin, Lura Kay Mosley, and Bonnie Harper. The majorettes were an important part of any marching band performance. Their skills and grace were evident at every football game. (Courtesy of Jewelle Allen.)

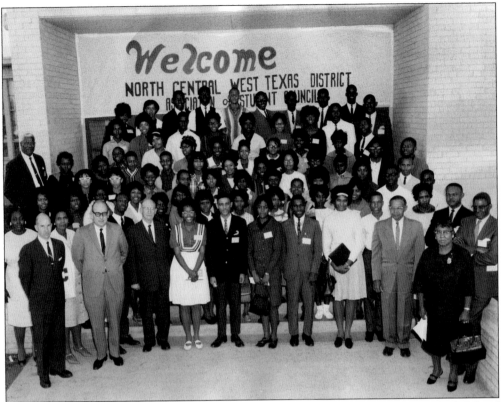

In addition to council members throughout the district, here are those from Carver High School who attended the 1965 North Central West Texas District Association of Student Councils, including students, administrators, and faculty. Included are Principal Arthur Champion, Susie Foster Neal, L. O. D. Williams, Jewelle Allen, Johnnie Delores Griffin, Bonnie Graves, Lillie Miller, Jimmie Vaughn, Terrance Woods, Buddy Allen, John Lewis, Adelle Ammons, Bennie Turner, and Beverly Crow. (Courtesy of Jewelle Allen.)

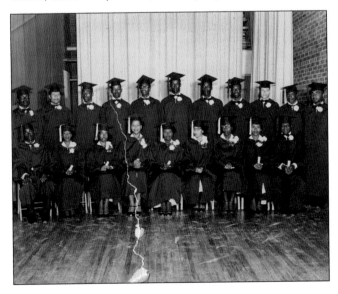

Pictured are members of the Carver School class of 1954; from left to right are (first row) Elton Ray Lawrence, Opal Clark, Wilma Jean Smith, Willie Jean Jones (McGhee), Robbie Henderson, Alga Faye Brinkley, Ruth Jean McClellan, Ruby Johns, and Clarence Ingram; (second row) Edgar "Jabbo" Johnson, Robert Hall, unidentified, Lawrence Fortson, J. L. Langston, Virgil Sanders, Clyde Hooker, Willie Fred Lindsey, unidentified, Cecil Brown, and Aaron Young. (Courtesy of W. Jean McGhee.)

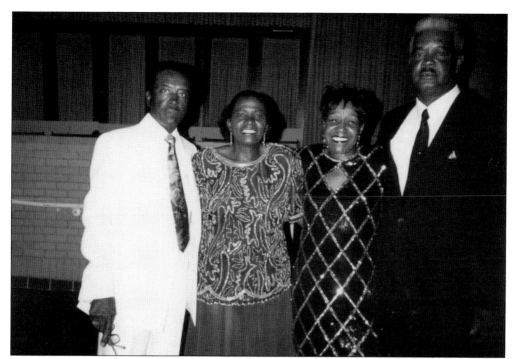

Pictured is the Carver School reunion for the class of 1956: from left to right, Joe Young, Alzia Dean Smith, Vivian Brown, and Travis Askew. Carver reunions are very well attended and usually include a parade, a picnic, a social gathering, and a closing religious ceremony held at various parks, venues, and churches in the community. (Courtesy of Alzia Dean Smith.)

Courtney Allen is pictured as she graduates from Spelman College in Atlanta, Georgia. Courtney is the daughter of Amarillo educators Johnny and Jewelle Allen. She is the sister of Buddy and James Allen; all were raised in Amarillo and were longtime members of Johnson Chapel AME Church. She currently resides in Atlanta, Georgia. (Courtesy of Jewelle Allen.)

The Carver High School class of 1956 celebrated their 50th reunion in 2006. Alzia Dean Smith decorated her vehicle to be in the parade that year, as pictured. Many of the reunion classes are very close and very dedicated to their former teachers still living in the area. This great sense of respect for these educators has never faltered. (Courtesy of Alzia Dean Smith.)

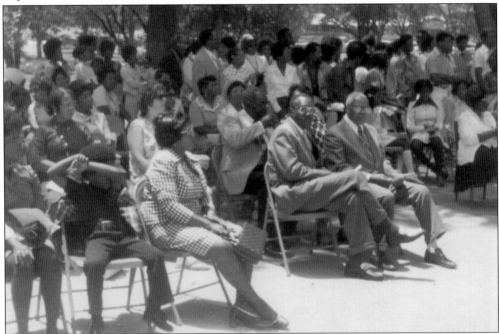

Carver reunion attendees take part in a religious ceremony in Thompson Park. This marks the last day of the celebrations, as former students and well-wishers plan to travel back home to their cities across the nation. The Carver reunions are held every two years, and fellow students share the importance of staying in contact with each other. They have a tremendous bond, as they share a piece of history that will never be repeated. (Courtesy of Jewelle Allen.)

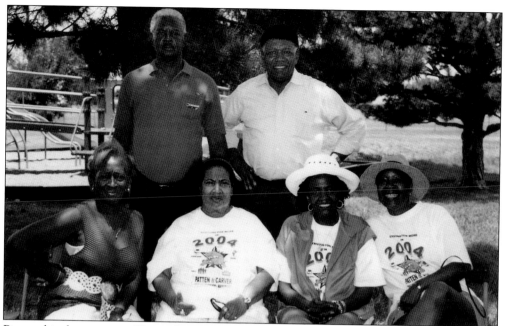

Pictured is the reunion of Patten/Carver School's class of 1956. Classmates in this 2004 picture include, from left to right, (standing) Travis Askew and Bobby Thomas; (seated) Doris Smith, Elaine Washburn, Alzia Dean Smith, and Carrie Austin. Oftentimes this is the only occasion for the classmates to share their experiences, especially if they live out of town and far away. (Courtesy of Alzia Dean Smith.)

This picture shows Amarillo native Farrah Stuart Williams in 1982 with her first-grade classmates from St. Mary's School. Farrah is in the top row, fourth from the left. She is the daughter of Harold and Claudia Stuart, longtime residents. Farrah later attended Amarillo High School and was a starting member of the state championship girls' basketball team, winning back-to-back victories in 1993 and 1994 as the Amarillo Sandies brought home the gold. She later attended West Texas A&M University. (Courtesy of Claudia Stuart.)

Hershal Mitchell attended and played basketball for Amarillo Junior College. The team was known as the Badgers, the school mascot. Amarillo College had a vibrant program until athletics were budgeted out in the early to mid-1980s. To this day, Amarillo College is well regarded as a premiere campus in the state and nation. (Courtesy of Fransetta Mitchell Crow.)

David Mitchell, a Carver graduate, played basketball for Prairie View A&M University. Prairie View A&M is consistently listed as a renowned campus for engineering programs and is a member of the Texas A&M University System. David, Hershal, Victor, Fred, and Morris are sons of Hershal and Lena Mitchell. (Courtesy of Fransetta Mitchell Crow.)

Victor Mitchell, a graduate of Amarillo High School, played basketball for the Amarillo Junior College Badgers. At 6 foot, 8 inches, he also played one year at the University of Kansas. There he averaged 8.1 points and 5.6 rebounds for the regional semifinalist Kansas team. (Courtesy of Fransetta Mitchell Crow.)

Fred Mitchell, a graduate of Palo Duro High School, was at one time the University of North Texas's leading scorer. The Mitchell basketball stars shown on these two pages were known as "the first family of AISD basketball stardom." All four brothers made the Texas Panhandle Hall of Fame. The basketball stars have another brother, Morris Mitchell, an ordained minister and pastor of Mount Olive Baptist Church. (Courtesy of Fransetta Mitchell Crow.)

Ron Shanklin, a Carver High School graduate, played football at North Texas State University and for the Pittsburg Steelers. He later coached for the University of North Texas. His older brother, Don, a Carver graduate, played for the University of Kansas and was MVP in the 1969 Orange Bowl. He played for the Philadelphia Eagles, the Canadian Football League, and the World Football League. Other Amarillo standouts were William Thomas of Palo Duro High School, playing for Texas A&M University and the Philadelphia Eagles; and Oscar Shorten Jr., a Tascosa High School graduate, playing for Abilene Christian University and the Chicago Bears. (Courtesy of Willetta Jackson.)

Evander "Ziggy" Hood was a football standout at Palo Duro High School. He is the son of Charles Hood and Mary Payne. After graduating from Palo Duro High School, he went on to play Division II–Big XVII football with the University of Missouri. As a member of the Mizzou Tigers football team, Ziggy has won many NCAA awards and accolades. He is also a member of Johnson Chapel AME Church. (Courtesy of Betty Hood.)

Five

Fraternal Organizations
All around the Town

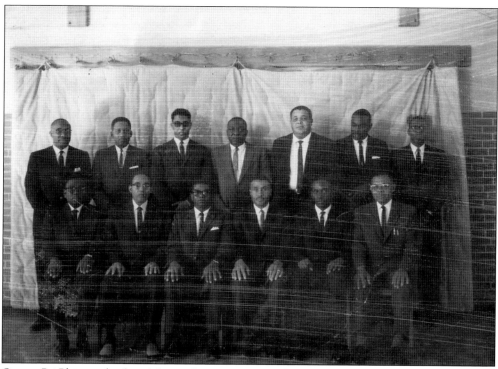

Omega Psi Phi was the first African American national fraternity to be founded at a historically black college, namely Howard University in Washington, D.C., on November 17, 1911. The Amarillo chapter was founded by men seeking to make a difference in the lives of black people and honoring the slogan of the fraternity, "Everything rises and falls on leadership." Pictured are a few of those good men: Lorenzo Person, John Jackson, Rothschild Ellison, E. B. Johnson, Ike Avery, Billy Hisbon, Henry Crawford, Leroy Ragster, Dr. Richard Jones, Arthur Champion, and Gillespie Wilson. Dr. Richard Jones also served as president of the Amarillo branch of the NAACP. (Courtesy of Milton Young.)

Scholarship is one of the important programs of the Amarillo chapter of Omega Psi Phi Fraternity. The fraternity established the Gillespie Wilson Scholarship Foundation to award scholarships to deserving youth in Amarillo. Gillespie Wilson served as president of the Amarillo branch of the NAACP following Dr. Jones and fought the battle for school desegregation in Amarillo. At the time, the Amarillo community was very much divided on the issue. He had many death threats during the years of the civil rights movement. (Courtesy of Edna Taylor.)

Omega Psi Phi Fraternity members has as its motto "Friendship Is Essential to the Soul." Actively involved in the community, they have several programs, including Achievement Week, scholarship, social action programs, Talent Hunt, Memorial Service, Reclamation and Retention, College Endowment funds, health initiatives, and voter registration, education, and motivation activities. Each chapter also holds life membership in the NAACP. These men represent the membership in Amarillo in 1961. (Courtesy of Milton Young.)

The Gillespie Wilson Scholarship Foundation members and invited guests awarded scholarships at West Texas A&M University in the Buffalo Room on campus. These scholarships helped defray the cost of tuition and books for deserving students. (Courtesy of Edna Taylor.)

Members of Omega Psi Phi Fraternity gathered at a special celebration and awards program held in Amarillo in recognition of youth achievement. These men often mentored the youth of the community and supported them in their endeavors. (Courtesy of Milton Young.)

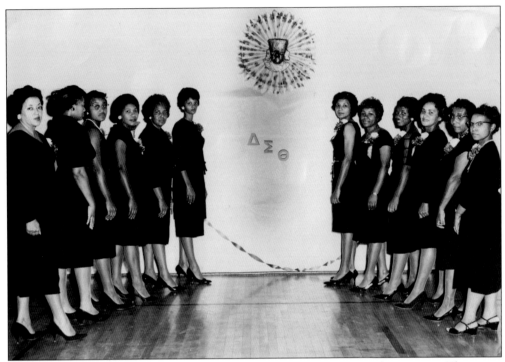

Delta Sigma Theta Sorority was founded on January 13, 1913, at Howard University. The motto was "Intelligence Is the Torch of Wisdom." The Amarillo Alumnae chapter of Delta Sigma Theta Sorority, Inc., was chartered in April 1962 in the home on Nina Faine, assisted by the Lubbock chapter and the regional director. The Five-Point Program of the sorority includes youth opportunities, mental health, library service, community service, and international goodwill. The founding charter members included, from left to right, Esther Cowans, Mary John Hands, Helen Neal, Thelma Herron, Nina Faine, Audrey Wilson, Jewelle Clay, Vivian Eddington, Lola Whitaker, Mary Helen Johnson, Cora Phillips, and Hessie Jones. Not shown are Rolla Jean Bentley and Janice Edwards. (Courtesy of Helen Neal.)

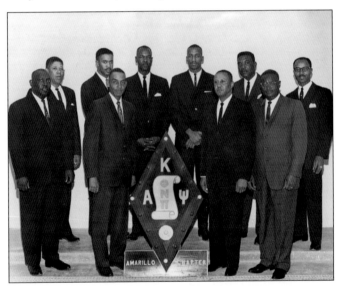

Kappa Alpha Psi Fraternity was founded on January 5, 1911, at Indiana University Bloomington. The motto was "Achievement in Every Field of Human Endeavor." Members of the Amarillo Alumni chapter included, from left to right, (first row) Arthur Brackeen, James Hilliard Sr., E. V. D. Richardson, and Dr. Phelgar Mosley; (second row) Secarl Blackburn, Elbert Reed, Clarence Harkins, Hayward Greene, Roger Scott, and Clemon Whitaker. (Courtesy of Clemon Whitaker.)

Charter members of the 1958 alumni chapter of Kappa Alpha Psi in Amarillo included Secarl Blackburn, polemarch (a position like that of president); Roger Scott, vice polemarch; Elbert Reed, keeper of records; Mitchel Dorsey, keeper of exchequer; E. V. D. Richardson, strategist; Arthur Bracken, lieutenant strategist; James Hilliard Sr., historian; Hayward Greene, board of directors; Clemon Whitaker, board of directors; and Clarence Harkins, board of directors. (Courtesy of Clemon Whitaker.)

Members of Kappa Alpha Psi Fraternity 2000–2004 included Gary Richardson, polemarch; Floyd Smith, vice polemarch; Clemon Whitaker, keeper of records; Lawrence Walker, exchequer; Allen Roberts, strategist; Coty Mitchell, lieutenant strategist; Rodney Wheeler, historian; Brandon Walker, reporter; Lawrence Walker, membership chairman; Gregg Scott, guide rights; Roger Scott, director of reclamation; James Adkins; Reynard Scott; Wes Harper; and L. C. Higgs. (Courtesy of Clemon Whitaker.)

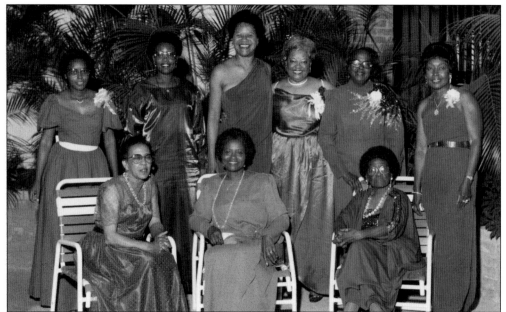

Zeta Phi Beta Sorority was founded in 1920 at Howard University in Washington, D.C. The Amarillo Alumni chapter of Zeta Phi Beta Sorority included, from left to right, (first row) Odeal Wilson, Pearlene Martin, and Annabelle Turner; (second row) Gwendolyn Hill Frost, Billie Ray, W. Jean McGhee, Johnnie Delores Robinson, Connie Jordan, and Gloria Foster-Young. (Courtesy of Lorenzo Woodberry.)

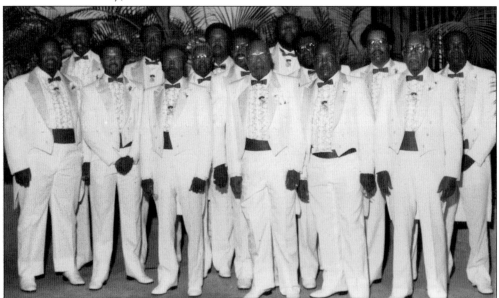

Phi Beta Sigma Fraternity, Inc., was founded at Howard University on January 9, 1914. Local projects involve the sponsorship of the Mary Hazelrigg Christmas Program and turkey dinners given to the poor at Thanksgiving. The Amarillo chapter consisted of, from left to right, Tom Jones, Morris Overstreet, Thomas Wesley, Jackie Montague, Joe Young, Charles Warford, Travis Askew, Robert Pleasant, Clifford Austin, Cellray Hamilton, Lorenzo Woodberry, Dizzy Turner, Don Lamar, Lorenzo Jordan, and Lewis Brazier. (Courtesy of Lorenzo Woodberry.)

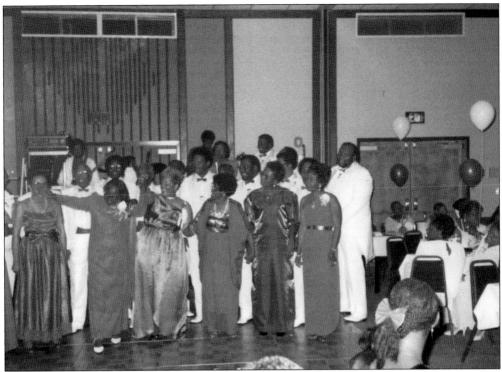

Phi Beta Sigma Fraternity and its sister organization, Zeta Phi Beta Sorority, regularly host special events in the community and sponsor various community service projects. Those pictured are, from left to right, (first row) Odeal Wilson, Connie Jordan, Johnnie Delores Robinson, Annabelle Turner, Billie Ray, and Gloria Foster-Young; (back row) Charles Warford, Lorenzo Jordan, Robert Pleasant, Travis Askew, Lorenzo Woodberry, and Cellray Hamilton. (Courtesy of Lorenzo Woodberry.)

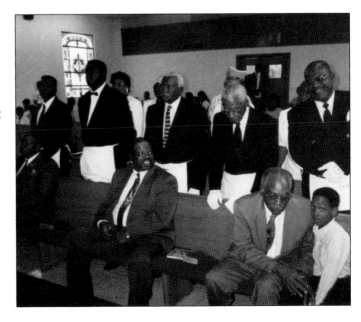

The Masons of Markwell Lodge No. 415 assemble at various churches in the community throughout the year. Those meeting at Johnson Chapel AME Church during the morning worship service include Lorenzo Woodberry (far right), Buster Alexander (second from right), Charles Kemp (third from right), and others. The members of the Steward Board of the church seated in front are, from left to right, Dizzy Turner, Anthony Phil Jones, and Richard Owens. (Courtesy of Lorenzo Woodberry.)

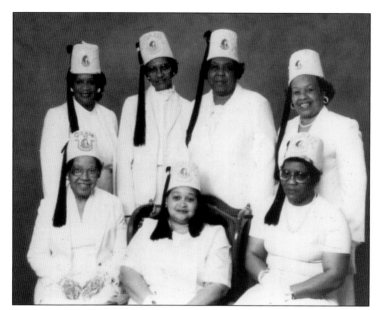

The Daughters of Isis, a social service organization, gathered in 1987. From left to right are (first row) Elnora Jackson, Beverly Shorten, and Ann Manning; (second row) Arvella Rowe, Iva Kelley, Frankie Scales, and Evelyn Allen. (Courtesy of Arvella Rowe.)

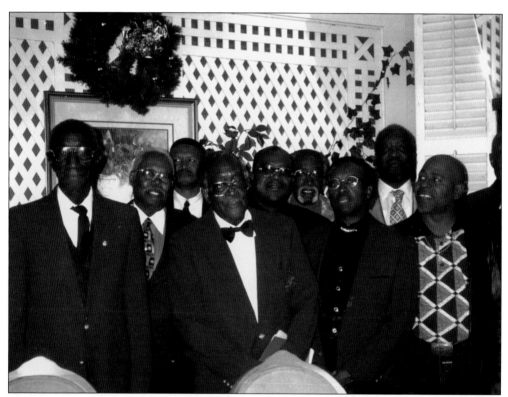

The Shriners gather for various and sundry community programs, always willing to support local causes. Those pictured are, from left to right, Doc Allen, Charles Warford, Hubert Scales, Lorenzo Woodberry, Lonzy Morrison, Joe Young, Herbert Williams, Datra Hollings, and Cleveland Austin. (Courtesy of Lorenzo Woodberry.)

Six

SOCIAL EVENTS
THEN AND NOW

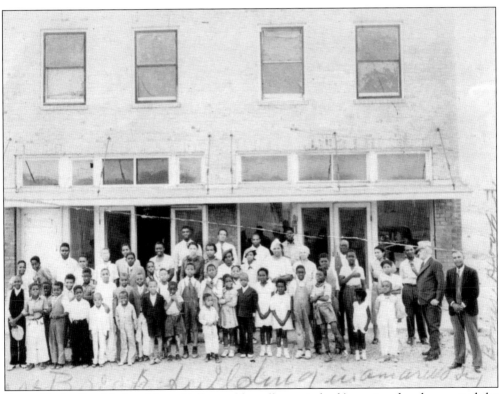

Bones Hooks (far right) and Jerry Calloway (the tall man in back) mentored and supported the youth of the community. Here they are gathered in front of the first brick building in Amarillo, built by Hooks. This appears to be a gathering of the Dogie Club members and their families. Boys in the Dogie Club learned how to set and achieve goals and develop respect for themselves and for others. (Courtesy of Amarillo United Citizens Forum.)

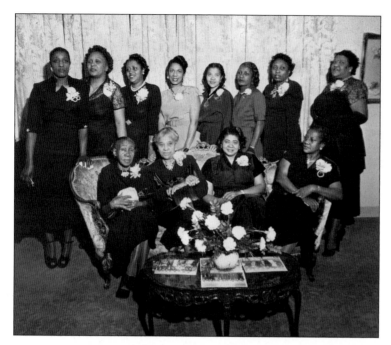

The ladies of the community formed several women's clubs. The purpose of all of these clubs was to bring women together and elevate them in some way. This is the Self-Culture Club, which focused on appreciation of the arts. The women read poetry and literature and discussed the other fine arts. This picture was taken on March 28, 1952, at one of their meetings. (Courtesy of Amarillo United Citizens Forum.)

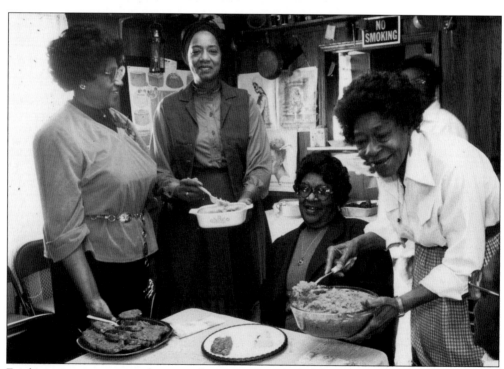

Food is an important part of any social activity. Here the ladies are cooking soul food as a way to retain their heritage. They were cooking in the old nurses' building that sits beside the cultural center. Bertha Miller is seated, with Johnnie Savage (second from left) and Evelyn Moore (left) offering the dishes. The other two people are unidentified. (Courtesy of Amarillo United Citizens Forum.)

Prenis Williams (far left) was director and president of Amarillo United Citizens Forum for six years on a volunteer basis. Also pictured are Gloria Foster Young (second from right), who taught music at Carver High School and was part of the jubilee singers there, and Linda Williams (right). The fourth person was not identified. (Courtesy of Amarillo United Citizens Forum.)

Class reunions are social events that happen almost every year. Here are some of the members of the graduating class of 1956 at a Carver reunion in 2006. They were celebrating their 50th reunion. Carver alumni are loyal to their alma mater, and many come from far distant cities to be a part of these reunions. (Courtesy of Arvella Rowe.)

The big social event for the Daughters of Isis is their Egyptian Tea. This one took place in 1997. Their creed says, "We hold firm to the belief that regardless of how much we say we love our neighbors unless we are willing to care and share we 'are as a sounding brass, or a tinkling cymbal.' Therefore we want to do more in the service of others each day. Isis was merciful, kind, and loving. We wish to possess these traits also." (Courtesy of Arvella Rowe.)

"T" Earnest Barringer, Ron Williams, and Floyd Smith, pictured here from left to right in 2003 in their Amarillo night club, pose for the cameras. The three partnered to bring soulful sounds and rhythm and blues performers to Amarillo, Texas. The three partners also participated in several community activities and won many awards for their cooking talents. "T" served as vice president of the NAACP. Ron, "T," and Floyd volunteered on a regular basis for Amarillo Habitat for Humanity, where they taught classes and mentored new homeowners. (Courtesy of Gwen Williams.)

The Community House near Hilltop School was where many social activities took place before the Black Historical Cultural Center was built. Here Arnold McGilbray (center) is being recognized by Marvell White (left) and Buster Alexander as Father of the Year for his support and mentoring of the community. (Courtesy of Amarillo United Citizens Forum.)

"Together We Can Build" was the motto of the group who wanted to build the new cultural center. This planning meeting took place at Carver High. It took a lot of hard work and a lot of fund-raising, but in the end, the Black Historical Cultural Center became a reality. Today it is the site of many social and cultural events, including community meetings, wedding receptions, after-school programs, banquets, and awards ceremonies. (Courtesy of Amarillo United Citizens Forum.)

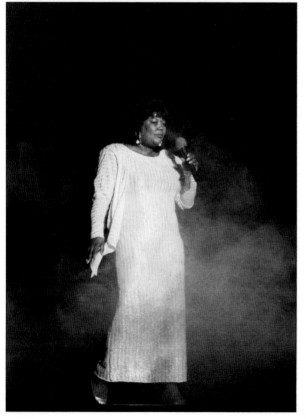

Every year, the community celebrates Black History Month and Dr. Martin Luther King Jr. Day. Marvell White dramatized picking cotton for a Black History Month event. White is an effective organizer and was important in starting both the Community House and the cultural center. She also organized many of the events for Black History Month. (Courtesy of Amarillo United Citizens Forum.)

Fransetta Mitchell Crow is a woman of many talents. Here she is performing jazz at the Globe News Center for the Performing Arts in Amarillo. She has a degree in mass communications and radio/television production from Amarillo College and has certifications in eight other areas. When she is not singing, she defines herself as a political and community activist. (Courtesy of Fransetta Mitchell Crow.)

Weddings are a time for families to come together and celebrate. The Hines wedding was definitely a high-class affair. From left to right are Allison Hines, Donald Bush, Sandra Nickerson, groom Leonard Nickerson, bride Ernice Vernell Hines, Melva Hines, Cecil Nickerson, Delores Andrews, Franklin Huff, Francis Jo Lee, and Carolyn Gipson. (Courtesy of Amarillo United Citizens Forum.)

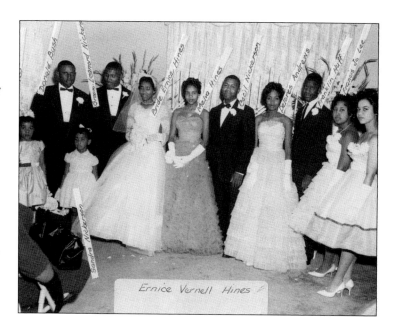

Juneteenth is celebrated every year. It was on June 19, 1865, that slaves in Texas were officially declared free. Ever since, this day has been remembered with picnics, song and dance, and days off from work. Juneteenth became an official state holiday in 1979 and has spread from Texas to many other states. Dancers perform in front of the cultural center. This is a usual event in Bones Hooks Park and Hines Memorial Park, along with musical performances and beauty pageants. (Courtesy of Mount Zion Missionary Baptist Church.)

Sometimes just getting all the family together for church can be an event. Here Morris Overstreet poses with his family, including his wife, Brenda, and his sister, Gloria Pearson, and her husband, Frank Pearson, standing in the back, on the steps of Mount Zion Missionary Baptist Church. Overstreet served as Potter County judge, court at law No. 1, and he was always active in the NAACP. (Courtesy of Mount Zion Missionary Baptist Church.)

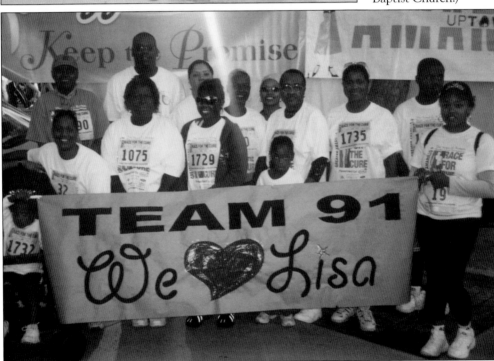

The Amarillo community supports its own. Here a group of people from Johnson Chapel AME Church join the Race for the Cure in honor of Lisa Cherry. The Delta Sigma Theta Sorority, of which Cherry was a member, sponsors a breast cancer awareness program at the Black Historical Cultural Center every year. Cherry is remembered as being kind, compassionate, and of deep faith. Psalm 91 was her favorite scripture. (Courtesy of Betty Hood.)

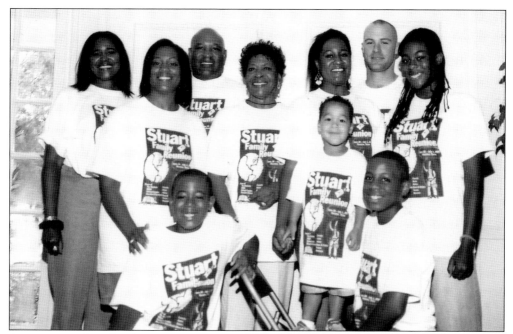

Any occasion for a family reunion means good fellowship, food, and fun. Here the Stuart family, gathered for the reunion event in 2007, includes, from left to right (first row) Jonathan Shorten, Langston Williams, and Christian Shorten; (second row) Dietra Lee, Claudia White (great-grandmother to Langston and Maya Williams), Farrah Williams, and Raquelle Lawrence; (third row) Claudia and Harold Stuart and Evan Williams. Farrah and Evan Williams attended West Texas A&M University in Canyon, and Dietra is a graduate of Texas A&M University in College Station. (Courtesy of Claudia Stuart.)

ABOUT THE AUTHORS

Prof. Claudia Stuart teaches in the field of sociology and criminal justice at West Texas A&M University and is a licensed master social worker (LMSW). Born in San Antonio, Texas, she has traveled around the world most of her life, having been raised in a military family. Very active in church and community, she serves on many boards and commissions and as a consultant to social service and law enforcement agencies. As a public speaker, Stuart frequently participates on panels and forums and makes guest appearances in the media. Penguin art is her current passion. She is the recipient of numerous teaching and community service awards and is an award-winning poet with several books of poetry, including *My Private Stock*, *Expressions*, *All Along Life's Journey*, *Living Out Loud*, and *Sociology, the New Millennium, 2nd Edition*.

Dr. Jean Stuntz teaches Texas and Spanish borderlands history at West Texas A&M University in Canyon, Texas. She specializes in women's history of the Southwest. She was born in Orange, Texas, and since moving to the panhandle has received many awards for her work. She frequently presents at conferences on the topics of Southwest studies and the rights of women. Stuntz is active in her church and the arts and enjoys learning and teaching about different cultures. Jean is the prize-winning author of *Hers, His & Theirs: Community Property Law in Spain and Early Texas*. When not teaching or writing, Jean enjoys making and collecting various forms of art.

ACROSS AMERICA, PEOPLE ARE DISCOVERING
SOMETHING WONDERFUL. *THEIR HERITAGE.*

Arcadia Publishing is the leading local history publisher in the United States. With more than 5,000 titles in print and hundreds of new titles released every year, Arcadia has extensive specialized experience chronicling the history of communities and celebrating America's hidden stories, bringing to life the people, places, and events from the past. To discover the history of other communities across the nation, please visit:

www.arcadiapublishing.com

Customized search tools allow you to find regional history books about the town where you grew up, the cities where your friends and family live, the town where your parents met, or even that retirement spot you've been dreaming about.